"CUT! PRINT!"

Foreword by
Academy Award Winner Charlton Heston

FOREWORD

When I came out to the Coast from New York to do my first film, puppy-fat and confident, I was not only certain that I had mastered Broadway (from the staggering total of four plays there, three of them flops), but I was also sure I'd find out all I needed to know about films in a week or so. After all, how tough could it be? Sit in the screening room and run a couple of dozen old flicks to see how they did it, and we're away, right? Sure. . .

In the common experience of almost every actor who's ever faced a camera, I found myself before long on location with a Western, on top of the Black Hills in South Dakota, not quite as sure as I had been that I knew all about films. Still, I at least knew how to ride, and it was a pretty good script and a very good part, and the director was George Marshall, who's been directing movies longer than anyone else still at it, wiping the wet from behind the ears of callow young stage actors since before I was born.

Things went along smoothly enough (as I said, *George* knew what he was doing), until the day we started one of the larger sequences in the film, involving several hundred Sioux from the Rosebud Reservation, a few dozen buffalo, five or six very high-priced stunt men, a Chapman boom with the forty-foot extension. . .and me. My contribution for the day consisted of riding as fast as possible down a slope on a flag cue, missing Sioux, buffalo, and stunt men, and arriving in place simultaneously with the booming camera to deliver one line in the general direction of the buried mike. Everyone was in place and ready as I mounted

HENNESSY

up, but I turned to George for a last conference on the line I had. I proposed to him a rather intricate reading based on an obscure motivation that escapes me now, but George heard me out with the patience born of years behind the camera, and his own equable, if laconic, nature. When I'd finished, he cocked an eye at me, then at the mounted men scattered for half a mile over the hillside, and the boom whining against the balance of its counterweights. "Look, kid," he said at last. "In this business, the first thing is not whether you can act, but can you ride a horse to a mark."

That remains one of the most useful pieces of direction I've ever had in films. In the years since then, I've learned a good bit (though I'm constantly discovering that there's more and more about which I know less and less—a possibility that somehow escaped me when I was twenty-two). It staggers me to recall, though, that when I first set foot on a sound stage, I didn't even know what a mark *was*.

This volume would have told me. It will also explain several hundred other things you should know if you make films, and might want to know it you're interested in them. I think it's a fine idea, and fills, as they say, a long-felt need.

Charlton Heston

"CUT! PRINT!"

THE LANGUAGE AND STRUCTURE OF FILMMAKING

By TONY MILLER and
PATRICIA GEORGE MILLER

A DACAPO PAPERBACK

Library of Congress Cataloging in Publication Data

Miller, Tony.
 "Cut! Print!"

 (A Da Capo paperback)
 Reprint of the ed. published by Ohara Publications,
Los Angeles.
 1. Cinematography — Dictionaries. 2. Moving-
pictures — Dictionaries. I. Miller, Patricia George,
joint author. II. Title.
 TR847.M54 1977 778.5'3'03 77-4907
 ISBN 0-306-80017-9

ISBN: 0-306-80017-9

First Paperback Printing 1977

This Da Capo Press paperback edition of *"Cut! Print!"*
is an unabridged republication of the first edition published in
Los Angeles in 1972. It is reprinted by arrangement with
Ohara Publications, Inc.

© Ohara Publications, Incorporated 1972

Published by Da Capo Press, Inc.
A Subsidiary of Plenum Publishing Corporation
227 West 17th Street
New York, N.Y. 10011

DEDICATION

Our thanks to all the actors—young and old—who, during their stay
with the Film Industry Workshops, asked us what "Strike the
Broad" and "Kill the Baby" mean. Special thanks to Mr. Gordon
Stulberg, Mr. Bernard Barron and Mr. Robert Norvet, without
whose help it wouldn't have happened.

ABOUT THE AUTHORS

In addition to their years of experience as Founders and Directors of The Film Industry Workshops, Inc., Tony Miller and Patricia George Miller bring to this book years of working experi-

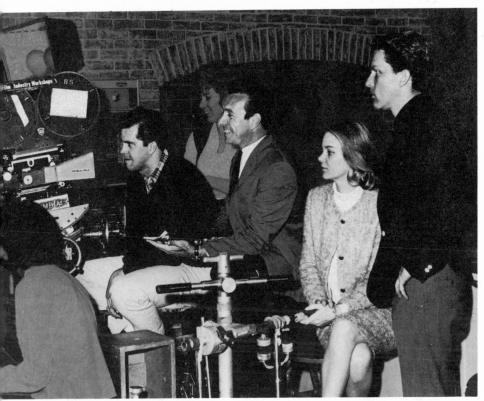

Cameraman Ross Kelsay, Director Arthur Hiller, Patricia George Miller and Tony Miller on the set of the Film Industry Workshops, Inc., during a working session.

ence in films and television as well as a background that includes the Broadway stage, summer stock, little theatre and radio.

Their work with FIWI has made them aware of the need for a useful addition to the frame of reference of those already in the film business and those considering it as an occupation.

PREFACE

Before you glance through "CUT! PRINT!" and start screaming, "But they left out...", and "Why didn't they include...", let's get our point across and, perhaps, avoid all the moans and groans.

This volume is not a technical manual. It isn't for the lens hound, the f-stop fanatic, the film gate fan, the sprocket and claw movement gang. It provides a familiarity with the film industry and its general, everyday vernacular.

Some of the words and phrases have been in use since the days of the hand crank; others are fairly new. Some terms will not become part of the language but will only fill a momentary need in an industry that is constantly changing. Others will find a permanent place in the language.

We've tried to take care of the day-to-day needs of the newcomer to the business so that 'Strike the Broad' and 'Kill the Baby' won't come as a shock. But knowing that "talk" isn't enough, we have included glimpses of other facets of the film business which we feel will be of interest and help to the newcomer as well as the veteran.

We know you'll find it useful, so read on.

CONTENTS

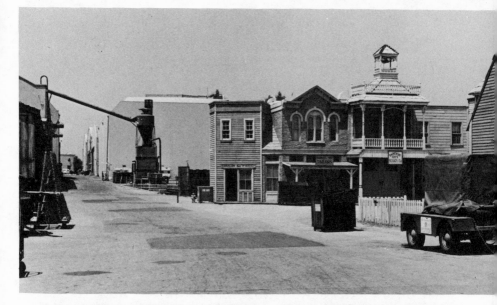

THE STUDIO COMPLEX

The following map and photographs of CBS Studio Center in Studio City, California are an example of what can be encompassed on a motion picture lot in the center of a major metropolitan area.

Due to the proximity of automobile traffic and overhead aircraft, dialogue shot on the back lot areas must be dubbed—not an unfeasible task when one considers the expense involved in the alternate procedure of moving an entire company to location.

The authors extend their gratitude to Mr. Robert Norvett, Mr. Ed Denault, and the many department heads of CBS Studio Center for their assistance in the preparation of this book.

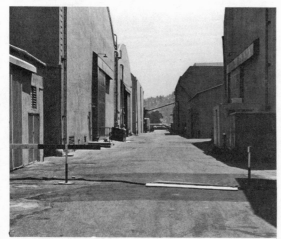

These two photos show the proximity of the back lot to the studio street bordered by sound stages.

Photos by Clarke Lindsley

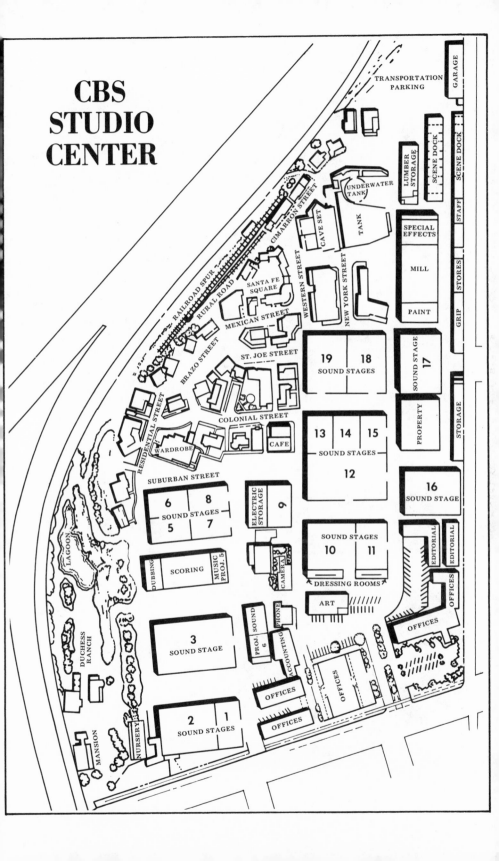

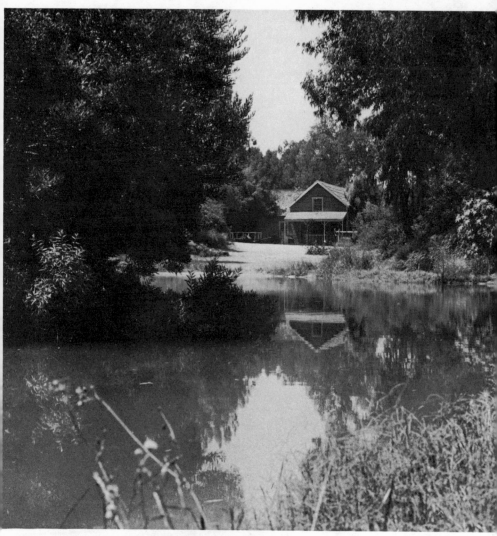

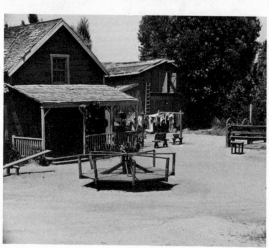

The shot above, which could have been taken in Georgia, Northern California or upstate New York, was taken on the back lot. It's a view across the lagoon to the Duchess Ranch. The small photo to the left is a close-up of the Duchess Ranch buildings, which can be, and have been, converted and redressed in so many ways that although they've been seen in hundreds of different films, they've never been recognized as the same buildings.

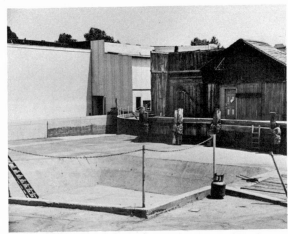

The tank in which both surface and underwater photography is made.

A "city street" on the back lot.

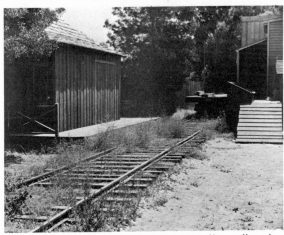

The "Dodge City Station" and many other railroads.

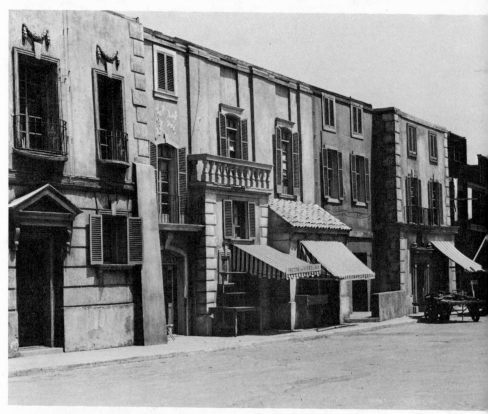

Here's Rome, and many other European city streets! Just change the shop signs, as well as the extras' costumes, and you've got a whole new city; perhaps a whole new era.

An example of Main Street Suburbia or Rural America on the back lot.

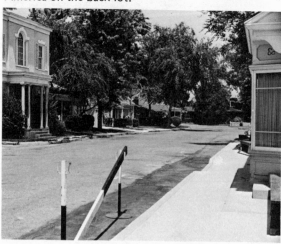

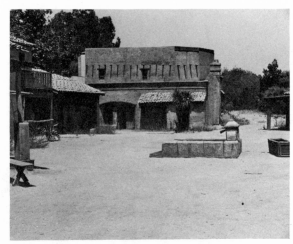

This scene has portrayed many old and contemporary Mexican villages.

And here's the old West. A close look will show the contemporary house on the hill in the background. Capable film crews have always managed to shoot around it.

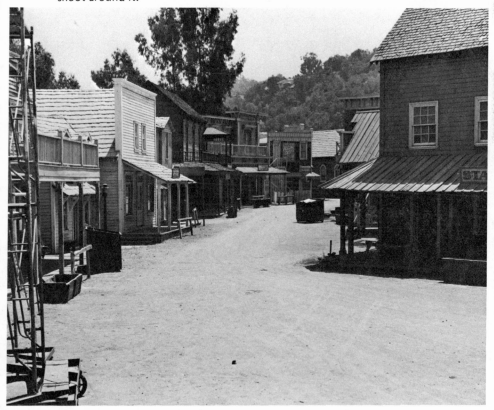

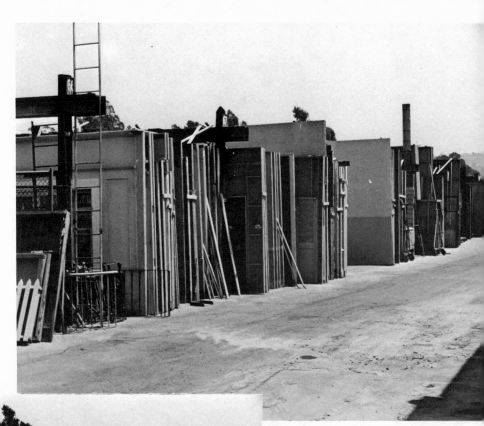

The set walls and parts of structures from the many shows produced on the lot are used and re-used.

Just a part of the lumber which is stored and ready to use for set construction.

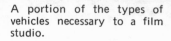

A portion of the types of vehicles necessary to a film studio.

STUDIO DEPARTMENTS AND PERSONNEL

As you can see from the preceding section, a film studio is a complex piece of property. Essentially, it is a manufacturing plant and, as such, is as complex as an automobile factory, a ship building yard or an aircraft plant. The only difference is the product; in this instance, hopefully, something artistic, something that will touch the audience in some emotional way.

Any manufacturing plant needs management—top level management to supervise all of the departments, and department heads to supervise the smooth running of the plant so that the product can be made without delays and problems. It's essential that the function of the factory never become more important than the product it makes, and that takes highly qualified executives, studio managers and department heads.

The following section is an idea of just how many departments go into the smooth running. The responsibility of each department and the services performed are shown in italics.

Studio Management

DEPARTMENT HEAD
(A studio executive)
PRE-PRODUCTION
PRODUCTION
POST-PRODUCTION
PLANT MANAGEMENT
LEGAL DEPARTMENT
HOSPITAL
PLANT MAINTENANCE, SECURITY, ETC.

Studio Management is responsible for all departments necessary to maintain the studio property itself, such as plumbing, clean-up crews, painters, air conditioning and studio security guards—everything it takes to run a large business establishment with a manufacturing plant.

Editorial Department

DEPARTMENT HEAD

SUPERVISING FILM EDITOR
FILM EDITOR
ASSISTANT FILM EDITOR
APPRENTICE FILM EDITOR
NEGATIVE CUTTER
EFFECTS EDITOR
MUSIC EDITOR
FILM LIBRARIAN
Stock footage

Art Department

DEPARTMENT HEAD

ADMINISTRATIVE ASSISTANT
UNIT ART DIRECTOR
ASSISTANT ART DIRECTOR
ILLUSTRATOR
MODEL MAKERS
LEAD MAN SET DESIGNER(S)
(drafting)
SENIOR DRAFTSMAN
JUNIOR DRAFTSMAN
CLERICAL PERSONNEL
(drawing files)
RESEARCH
BLUEPRINTING

Camera Department

DEPARTMENT HEAD

CAMERA MAINTENANCE
TECHNICIANS
MACHINISTS
CAMERA LOADERS

SHOOTING CREW
DIRECTOR OF PHOTOGRAPHY
CAMERA OPERATOR

(Camera Department Continued)
FIRST ASSISTANT
SECOND ASSISTANT

Sound Department

DIRECTOR OF SOUND,
RESEARCH,
QUALITY CONTROL

OPERATIVE SUPERVISOR
(engineer)
PRODUCTION MAINTENANCE
SUPERVISOR

TRANSFER
MIXER
ENGINEER
RECORDER
MACHINE LOADER

DUBBING
MIXER
ENGINEER
RECORDER
MACHINE LOADER

SHOOTING CREW
MIXER
BOOM MAN
CABLE MAN

Wardrobe Department

DEPARTMENT HEAD

DESIGNERS
RESEARCH PERSONNEL
SEAMSTRESS
TAILOR
WARDROBE MASTER
WARDROBE MISTRESS

Construction Department

DEPARTMENT HEAD

PROP MAKERS
MINIATURE MAKERS

MAINTENANCE
PROP MAKERS
PAINT DEPARTMENT

SCENE DOCK
GRIPS
CRAFT SERVICE

BLACKSMITH
Ironwork and welding

UTILITY
PLASTER
NURSERY
LANDSCAPE

Grip Department

DEPARTMENT HEAD

PRODUCTION
KEY GRIP
BEST BOY
CRAB DOLLY OPERATOR
Additional grips for
operation of crane
GRIPS

CONSTRUCTION
PUSHER
(gang boss, lead man)
GRIPS

DIFFUSION AND SEWING
Making of scrims, nets,
gobos, flags, gels, etc.

Prop and Set Dressing Department

DEPARTMENT HEAD

SECRETARY
BUYERS, ASSISTANTS, ETC.
FOREMAN

ELECTRICAL FIXTURES
FOREMAN
REPAIRMAN
INSTALLER

DRAPERY, ETC.
FOREMAN
CUTTERS
SEWERS
UPHOLSTERY MAN
FLOOR COVERING MAN

SHOOTING CREW
DECORATOR
LEAD MAN
(assistant decorator)
SWING GANG MEN
Move furniture, hang pictures, etc.
PROP MASTER
ASSISTANT PROP MASTER

ANIMALS
WRANGLER(S)
TRAINER(S)

Electric Department

DEPARTMENT HEAD

ASS'T DEPARTMENT HEAD
SUPERVISOR OF MAINTENANCE
MAINTENANCE ELECTRICIANS
On-set repair and windmachine
operation (larger than 18")
RIGGING SUPERVISOR

RIGGING CREW
PRACTICAL FIXTURE MAN
POWERHOUSE GENERATOR
OPERATORS
SERVICE ELECTRICIANS
*Dressing rooms, work lights, red
lights, make-up tables, etc.*

SHOOTING CREW
GAFFER
BEST BOY
LAMP OPERATORS
(juicers)

Transportation Department

DEPARTMENT HEAD

SECRETARY
DISPATCHERS
SERVICEMAN
MECHANIC(S)
WASHER(S)
DRIVERS

The Transportation Department is responsible for providing production companies with transportation automobiles as well as the autos, trucks, tractors and other vehicles used in filming. It is also responsible for the horse vans, generator trucks and water wagon, and must see to every detail of location trucking, e.g. transporting everything from camera booms to toilet paper in anything from a small van to a double trailer. Transportation also picks up and delivers the film to labs and studios.

FILM PRODUCTION PROCEDURES

There are various alternatives in the movement of a property from the writer's typewriter, through the stages of pre-production, production and post-production, to the final screening for the audience. In some instances, a producer will acquire the property, make up his own package, take that to backers for financing and then to a distributor to make up the final part of the package, which is getting the eventually completed film into theatres.

The following charts, though not complete to the final detail, do give a general idea of production procedures and the complexity of the process.

PRE-PRODUCTION CHART

The writer sits alone at his (hopefully electric) typewriter and writes what he knows is one of the best films of the last ten years. He gives the manuscript to his agent, hoping for an immediate sale, which is seldom the case. From his agent, the script goes to a studio or independent producer and from there into pre-production. Then, if all the problems of budget, casting and production can be worked out, production begins. It's a long, hard road for all

AGENT-DIRECTOR

WRITER

AGENT

PRODUCER

involved, with difficult decisions to be made every step of the way; decisions involving not only money, but careers and reputations as well.

(The agent—really many different agents—keeps cropping up in this chart because all of the creative talents working on the production, from the writer and director to the actors, dancers and musicians, are represented by their agents in an attempt to get a better salary for their efforts.)

AGENTS—STARS

AGENTS—SUPPORTING ACTORS

STUNT PERSONNEL

CASTING DEPT.

ATMOSPHERE

STAND-INS

ARRANGER

COMPOSER

MUSICIANS

CONDUCTOR

EDITOR

ART DIRECTOR

LOCATION DEPT.

PRODUCTION DEPT.

ESTIMATING

TRANSPORTATION DEPT.

CONSTRUCTION DEPT.

PUBLICITY DEPT.

SHOOTING SCHEDULE

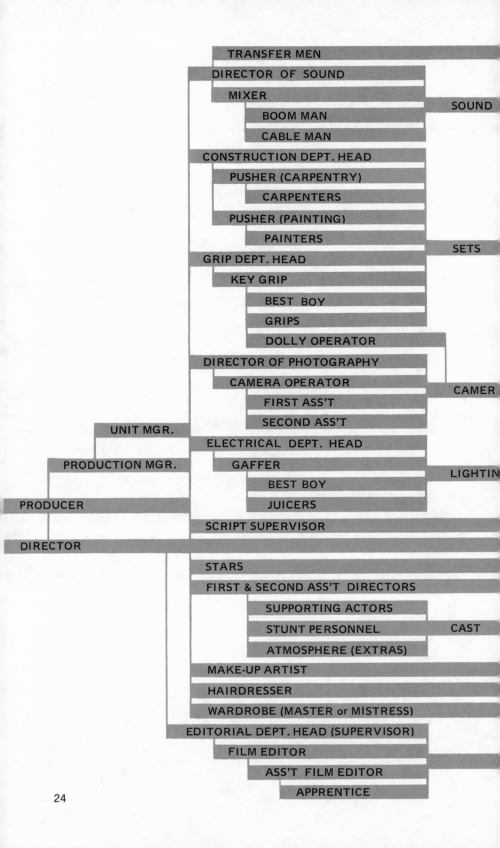

TRANSFER MEN

DIRECTOR OF SOUND

MIXER

BOOM MAN

CABLE MAN

SOUND

CONSTRUCTION DEPT. HEAD

PUSHER (CARPENTRY)

CARPENTERS

PUSHER (PAINTING)

PAINTERS

SETS

GRIP DEPT. HEAD

KEY GRIP

BEST BOY

GRIPS

DOLLY OPERATOR

DIRECTOR OF PHOTOGRAPHY

CAMERA OPERATOR

FIRST ASS'T

SECOND ASS'T

CAMER

UNIT MGR.

ELECTRICAL DEPT. HEAD

PRODUCTION MGR.

GAFFER

BEST BOY

JUICERS

LIGHTIN

PRODUCER

SCRIPT SUPERVISOR

DIRECTOR

STARS

FIRST & SECOND ASS'T DIRECTORS

SUPPORTING ACTORS

STUNT PERSONNEL

ATMOSPHERE (EXTRAS)

CAST

MAKE-UP ARTIST

HAIRDRESSER

WARDROBE (MASTER or MISTRESS)

EDITORIAL DEPT. HEAD (SUPERVISOR)

FILM EDITOR

ASS'T FILM EDITOR

APPRENTICE

PRODUCTION CHART

Production is sometimes called "organized chaos" and looks it, but in most instances the word organized is the key. The many people on the set know what they're doing and get it done, and done well.

During production of a film at a studio, there may be many scenes (that may or may not include the stars) which have to be shot away from the studio. This part of the film can be shot at the same time the studio filming is going on, by the Second Unit which in itself is a production company, with a production manager, director and assistants. Here's where the car chase, stunt footage and jump off the cliff are filmed. All of this footage must be coordinated with the First Unit footage so that all moves and directions will match in the final film.

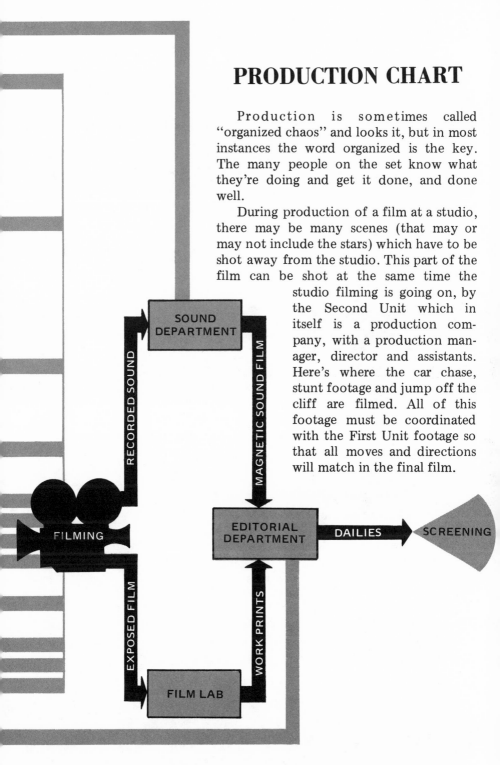

SOUND DEPARTMENT

RECORDED SOUND

MAGNETIC SOUND FILM

FILMING

EDITORIAL DEPARTMENT

DAILIES

SCREENING

EXPOSED FILM

WORK PRINTS

FILM LAB

POST-PRODUCTION CHART

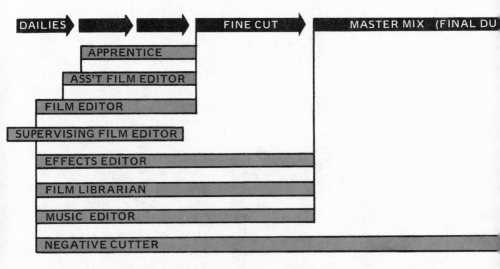

DAILIES			FINE CUT	MASTER MIX (FINAL DU
	APPRENTICE			
	ASS'T FILM EDITOR			
FILM EDITOR				
SUPERVISING FILM EDITOR				
EFFECTS EDITOR				
FILM LIBRARIAN				
MUSIC EDITOR				
NEGATIVE CUTTER				

Post-Production is sometimes referred to by people who weren't there during the production phase as "Let's see what we've got and can we make a movie of it?" This is a part of filmmaking that can also make or break a film. So many things the audience is never aware of (which is best) go into this part of the filmmaking; the heavy breathing of the star which was recorded during the filming of the on-foot chase scene, for instance. The breathing couldn't be heard because there was too much other sound interference during the shot, making that sound track unusable. So the heavy breathing is now recorded on a recording stage, and then added to the sound track of the film along with all the other necessary sounds that we take for granted: office sounds, street sounds, music background (from the portable radio in the picture), footsteps, doors closing, dishes and glassware clattering, and music in the restaurant. All of these sounds are

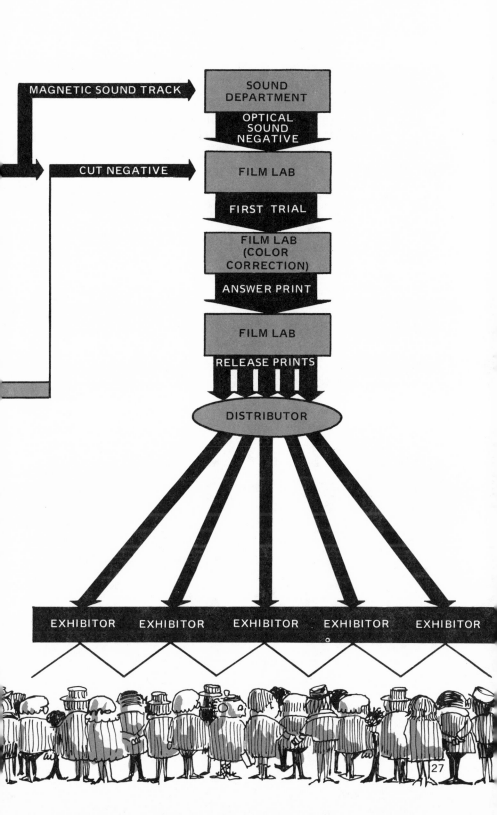

MAGNETIC SOUND TRACK

SOUND DEPARTMENT

OPTICAL SOUND NEGATIVE

CUT NEGATIVE

FILM LAB

FIRST TRIAL

FILM LAB (COLOR CORRECTION)

ANSWER PRINT

FILM LAB

RELEASE PRINTS

DISTRIBUTOR

EXHIBITOR EXHIBITOR EXHIBITOR EXHIBITOR EXHIBITOR

27

added in Post-Production where their level can be controlled so that they won't muffle or override the dialogue.

The recording stage is also where the music score is added... the music score that will also sell the picture through record sales and, perhaps, win an award at the annual Academy Awards presentation. The final details which polish a film are taken care of in Post-Production. The sales campaign is discussed, posters, newspaper, TV and radio advertising are decided. Finally, the film is framed and mounted for showing to the public.

GLOSSARY OF FILM TERMS

The following pages of definitions do not represent a technical manual, but rather a glossary which includes some technical terms that may be useful to the non-technical person, and, hopefully, as much of the "in" vernacular necessary to have some degree of familiarity for the person who doesn't need to know the difference between a kelvin and a grip.

In the belief that familiarity can breed security (rather than contempt) in the person who is fully aware of his business, we offer a collection of those definitions which we feel are most necessary for the actor and others in the business of film. We're sure that some readers will immediately be able to list thousands upon thousands of words and phrases we've left out, but after some years of research it is our belief that this collection fills the bill.

Illustrations by Dick and Dolores Hennessy

Academy Players Directory.
 See Directory.

ACE—American Cinema Editors
 An honorary professional society
 of feature-length motion picture
 and television film editors. Mem-
 bership is by invitation only.
 Quarterly publication: *The Cine-
 meditor.* Yearly award: 'Eddie'.

"Action"
 The order given by the director
 of the film—when the sound
 recording equipment and the
 film in the camera are running at
 filming speed—to indicate that
 the action within the shot is to
 begin.

Action
 What is occurring in the scene.

Actor
 The person employed to repre-
 sent to the audience a created, or
 biographical, character.

Added Scenes

Scenes added to the original concept; usually shot after the film has been completed.

Ad Lib

To create words or action on the spot.

Ad-Pub

Advertising-Publicity.

AEA—Actors Equity Association

The labor union which negotiates wages and working conditions for actors in the legitimate theatre. Monthly publication: *Equity Magazine.*

American Federation of Musicians

AF of M—American Federation of Musicians

The labor union that negotiates wages and working conditions for musicians in all fields. Monthly national publication: *International Musician.*

American Federation of Television and Radio Artists

AFTRA—American Federation of Television and Radio Artists

The labor union that negotiates wages and working conditions for performers in live television, taped television and radio. Publication: *Dial-Log.*

Agent

A person franchised by one or
more of the talent guilds or
unions to represent their mem-
bers in negotiating an individual
contract that includes wages,
working conditions and special
benefits not in a standard guild
or union contract. This is the
person the actor hopes will find
him work and help to build his
career.

AGMA—American Guild of Musical Artists

The labor union that negotiates
wages and working conditions
for performers in live opera,
ballet, all forms of live dance,
and concert singers. Quarterly
publication: *AGMAzine*.

AGVA—American Guild of Variety Artists

The labor union that negotiates
wages and working conditions
for variety performers, e.g. circus
acts, magicians, jugglers, comics,
club acts, fair acts, road shows
with no story, etc.

A.K.A.

Also Known As. Designation
used in a contract to indicate an
additional name used by the
same organization or individual.

**Association of Motion Picture
and Television Producers**

AMPTP—Association of Motion Picture and Television Producers

A trade association, comprised of motion picture and television producing organizations, which offers five major services to its members:

1. Negotiates labor contracts with the crafts, unions and guilds.

2. Acts as a code and rating administration which carries out a self-regulating code and also rates films for the audience. See Rating.

3. Central Casting. The placement and payment of extras in theatrical and television film production.

4. Contract Services Administration Trust Fund. Administers an apprentice program in primarily the crafts; polices and administers physical exams for senior members of the crafts who are over 65 years of age, as well as new members; administers a safety program which consists of monthly meetings and publication of comprehensive brochures on safety in various crafts; and maintains seniority rosters for the crafts.

5. Director Guild of America— Producers Apprentice Program. A program for apprentice assistant directors and production managers.

Anamorphic

A lens used to squeeze a widescreen image to a 35mm width while photographing. This process is reversed when projecting the final film, bringing the image back to normal width on a wide screen.

Animation

Making films by shooting a sequence of drawings or cartoons one frame at a time, each so slightly different that when they are run through a projector at a prescribed speed they appear to move.

Answer Print

The first combined print of a film made by the film processing lab, which will be used to set the standard for all following release prints.

Anthology Show

A series of programs in which the subject matter or characters are not necessarily consistent. Can also be called a series if it is always in the same time slot, or sponsored by the same company, or introduced or narrated by the same person.

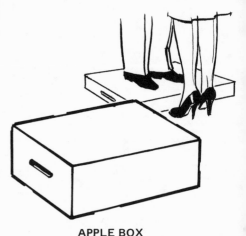

APPLE BOX

Apple Box

Used to raise actors or an object

to the correct height for the shot.

Arc Lamps
See Brutes.

"Arc Out"
An order given to an actor crossing in front of the camera to make the cross on a curving line, holding the same distance from the lens throughout the move to make it look as though the person were walking in a straight

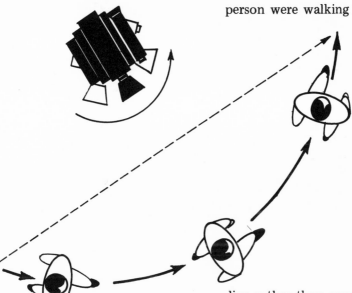

"ARC OUT"

line rather than coming closer to the camera and then away.

Art Department
Responsible for designing the sets for the film. It is frequently responsible for the overall production design. The art depart-

ment's work is usually done in close cooperation with the director of the film.

ASC—American Society of Cinematographers

An honorary professional society of feature-length motion picture and television film directors of photography. Monthly publication: *American Cinematographer.*

American Society of
Cinematographers

Aspect Ratio

The comparison of the width to the height of a motion picture frame.

Assistant Director

An assistant to the director of a film who maintains the necessary paper work that keeps the 'front office' up to date on the progress of filming. He is responsible for the presence of actors at the right time and place, and for the carrying out of the director's instructions.

Atmosphere

The transmission or reception of sound.

Audition

See Reading, Test, Personality Test.

Auto Gate

The entrance to the film studio, through which a car may be driven, with the proper permission.

Available Light

Filming without the addition of any artificial light.

B

Baby Spot
500 or 750-watt lamp.

Background Music
Music 'canned' or written especially to accompany a film. The music is meant to enhance the involvement of the audience in the subject matter of the film.

Backing
Either an enormous photograph or a life-like painted image on a fabric surface that is hung on a sound stage. It may be a city skyline, a countryside, a backyard, a view of the street outside the front door, etc., but usually represents an exterior. Sometimes called a cyc or cyclorama.

Back Lighting
Lighting toward the camera, shielded so it won't shine into the lens. Increases lighting contrast up to the extreme condition of a silhouette.

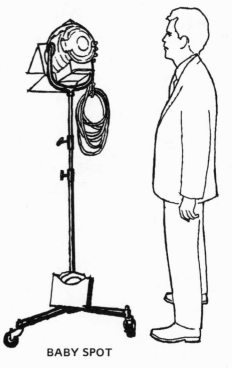

BABY SPOT

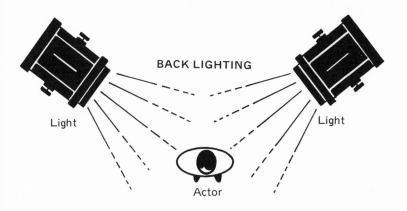

Back Lot

Area of the studio property which includes a western street, city street, suburban street, etc., for shooting 'location' exteriors without going on location.

Camera

Back-to-Back

The making of two or more films, either feature or television, in which there is an overlap of either budget, actors, crew or production involvement. The films can be produced concurrently or one following the other.

'Bananas on Bananas'

A description of what is thought to be too much of whatever is under discussion. The joke on a joke on a joke.

Barn Doors

Hinged doors mounted on the front of a studio lamp, which may be opened or closed to regulate light in a particular area of the set.

Barney

A padded cloth container which can be placed over the film camera, or blimped film camera, to cut down the noise of the mechanism. There is also a heated barney, for use in cold weather.

BARN DOORS

Best Boy

Gaffer's, or Key Grip's, assistant.

'Bicycling'

When an actor or director is involved with two projects concurrently or one immediately after the other.

Bin

The metal or metal-framed canvas container used to catch all of the out takes the editor will not be using. The 'face on the cutting room floor' isn't really there at all; it's in the bin.

BARNEY

'Biog'

A biographical film.

Bit Player

>An actor working in a small part in a film. His part is usually completed in one day, but it may run for a longer period of time. See Day Player.

'Biz'

>Business. Used to mean the entertainment industry or 'Show Business'. See The Business.

Blank

>A rifle or pistol cartridge that has a paper or plastic wad in place of the usual bullet. Blanks are used in filming to prevent injury, although the wad itself still presents potential danger if someone is too close when the weapon is fired.

BLIMP

Blimp

>The sound-proof housing which surrounds a film camera to prevent the noise of the camera mechanism from being recorded on the sound track.

Blow Up

>The increase in size of a film from 16mm to 35mm which is done in the laboratory for release to theatres. The term also applies to still photographs that are enlarged for display or promotion.

'Blue'

Used to describe material with a negative sexual inference. Sometimes called 'dirty'.

Blues

Not inferring sadness, but added pages or rewrites that are indicated by being printed on light blue paper. Pink and yellow paper indicate additional rewrites.

BNC—Blimped Noiseless Camera

Made by the Mitchell Camera Corporation, it is an NC camera in a blimp to reduce the noise level and allow the camera to be used on a soundstage for filming with dialogue recording. See Blimp, NC.

BODY FRAME

Body Frame, Body Pod

Used to assist in the support of a hand-held camera when in the field.

Boom

See Camera Boom.

Boom Man

An individual who operates the microphone boom that supports the microphone used to record dialogue in a scene. See Boom, Fishpole.

Boothman
> Film projectionist. The man who works in the projection booth.

Box Lunch
> Usually on location, the production company is responsible for the feeding of the company. They sometimes provide sandwiches, fruit, etc., individually packaged in boxes.

Box Office
> The place where admissions are collected at a theatre.

Box Office Draw
> What the film has to offer which will hopefully get the audience into the theatre: sometimes the talent in the film, the film subject matter, or the director of the film.

Breakaway
> A set or a hand prop, e.g. bottle or chair, constructed to break in a specific way on cue.

Breakdown
> Usually referring to the specifics of the cost of a film production. May also refer to the arrangements and scheduling of the various scenes and the order in which they are to be shot.

BROAD
(Double Broad)

Broad
> A light used for smooth, broad, soft lighting in sets.

Brute
> A light used in place of, or to supplement, sunlight, both inside and in exterior scenes filmed outside of the sound stage. Also called arc lights.

Budget
> The overall cost of a film production.

Bullhorn
> A portable, hand-held microphone and speaker in the same container, which is used on location for directing people who may be at a distance from the position of the director or assistant. The bullhorn has replaced the megaphone. Also called a hailer.

Business Manager
> The person who manages the actor's business and tax affairs and who, the actor hopes, will push the agent into finding work for his client.

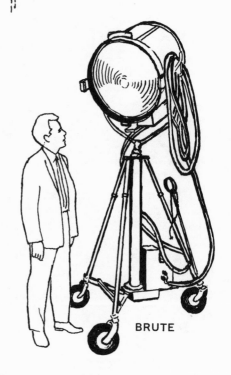

BRUTE

BULLHORN

C Stand

See Century Stand.

Call

The time that an individual member of the staff, cast or crew is expected on the set. This schedule is usually listed on the company call sheet and is the responsibility of the assistant director.

Call Sheet

The record used by the assistant director to keep track of who is required for filming and when. Sometimes a copy of this sheet is supplied to the actors in the film.

Camera

A mechanism which controls the movement of unexposed film behind a lens and shutter and which will determine the image and degree of light admitted to the film. The mechanism may also have a speed control.

Camera Angle

The field of view of the camera when it is set to shoot. The terms high, low and wide are based on an imaginary norm which approximates a 35mm camera with a two-inch (50mm) lens pointed at a scene from shoulder height.

Camera Boom

A mobile camera mount, usually

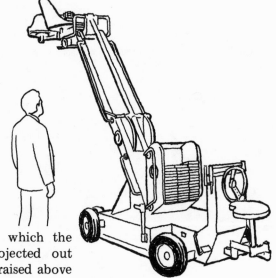

of a large size, on which the camera may be projected out over the set and/or raised above it. See Crane.

CAMERA BOOM

Camera Department

Responsible for acquiring and maintaining all camera equipment necessary for the filming of motion pictures. Also responsible for film handling, loading of film and liason with processing laboratory.

Camera Machine Shop

Responsible for maintaining all camera equipment and making whatever modifications and repairs may be necessary.

Cameraman

1. First Cameraman. Often called the director of photography or chief cameraman, he is responsible for the movements and setting of the camera and for the lighting of the scenes. Except in small production units, the director of photography does not as a rule operate the camera during actual shooting. 2. Second Cameraman. Often called the assistant cameraman or camera operator, he acts on instructions from the first cameraman and carries out the adjustments to the camera or operates the camera during shooting. 3. First Assistant Cameraman. Chief assistant to the camera operator. Often responsible for follow focus. 4. Second Assistant Cameraman. Assistant to the camera operator.

"Camera Noise"

A call from the mixer on a working set to indicate that he is picking up noise from the camera mechanism, in which case either another camera will have to be used, camera repairs will have to be made or additional smoth-

ering of the camera with a bar-
ney or blankets will be required.
See Barney.

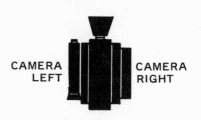

Camera Report

A form with carbon copies kept
with each magazine of film, on
which the assistant cameraman
records the footage of each scene
shot, the scene numbers, and
whether it is to be printed or
not. The camera reports go to
the processing lab, the camera
department and the production
department.

CAMERA
LEFT

CAMERA
RIGHT

"Camera Right", "Camera Left"

Directions to an actor to make
turns or moves. The directions
are oriented from the director's,
or camera's, point of view and
are thus reversed for the actor.
When facing the lens, the actor's
right is camera left and vice
versa.

Camera Tracks

Tracks of metal and/or 4' x 8'
plywood sheets which are laid

CAMERA TRACKS
(Plywood)

down to carry a dolly or camera boom. The tracks are used to ensure smoothness of camera movement.

Can

A container for film.

Canned Music

Music which has not been written for any specific film, but which has been recorded and catalogued by style in a library so that it can be purchased for use.

'Cans'

The soundman's earphones.

Carpenter Shop

Responsible for all wood construction on a studio lot, including sets, set pieces and special effects construction.

Casting Director

The person in charge of submitting and contracting actors to fill the required parts in a script.

Cattle Call

A large group of actors and actresses who are being seen in one mass call for selection in a film or commercial, rather than

by individual appointment. Such
a large group of people milling
about resembles the old-time cat-
tle drives.

Catwalk
See Rigging.

Central Casting
See AMPTP, No. 3.

Century Stand
Used to hold the various flags
necessary to reduce the intensity
of light or to block certain por-
tions of the light completely.
Also used to hold or support
branches of leaves or other ef-
fects related to lighting.

CENTURY STAND

Changing Bag
A light-tight, double zippered
bag in which a film magazine can
be placed in order to remove the
exposed film and re-load the
magazine. It is so constructed as
to allow the camera assistant to
reach in with his hands and
forearms without exposing the
film to light. Usually used away
from the studio since at the
studio magazines are loaded in a
dark room in the camera depart-
ment.

Character Man or Woman
Occasionally a star may play a

CHANGING BAG

character part, but usually the term refers to an actor or actress best suited physically for parts other than the romantic leads, juvenile parts or ingenue parts.

"Cheat the Look"

A direction to an actor to move his face in such a way that the camera can see more of it than the natural position would allow.

Child

Usually refers to an actor who is under the age of 15.

'Christmas Tree'

A small cart or dolly used to store and transport pieces of lighting equipment such as scrims, flags and cooks.

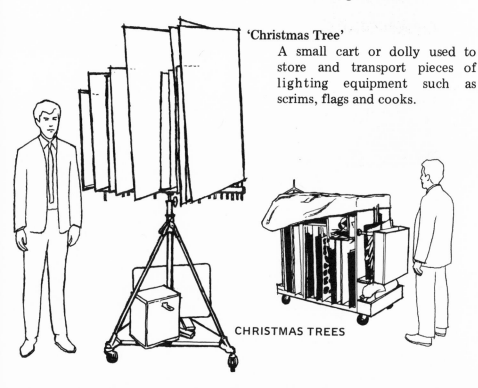

CHRISTMAS TREES

Cinema

Refers to motion picture. From the Greek *kinema*, meaning picture.

CinemaScope

A trade name for a process of photography and projection that involves an anamorphic lens camera or projector and an extra wide curved screen. It allows for the projection of a much larger than average picture. Many epic films have been made in Cinema-Scope because of the added impact of size on the audience.

Cinematographer

The director of photography. The person who carries out the technical aspects of lighting and photographing the scene. The creative cinematographer will also assist the director in the choice of angles, set-ups and mood of the lighting and camera.

Cinemobile

A trade name for a self-contained, mobile location motion picture making unit which carries both equipment and personnel and which ranges in size from the small equipment van to a large bus.

Cinex

Short tests strips of film which

are provided by the lab with the dailies to show the range of possible printing.

Clapper Boards

A pair of hinged boards which are clapped together in dialogue shooting when the picture camera and sound recorder are running at synchronous speed. The first frame in which the boards touch is then synchronized, in the cutting room, with the 'bang' noise, establishing sync between sound and picture tracks. In many modern types of sound recording systems an electronic marking system is contained inside the camera. See Slate.

CLAPPER BOARD

"Clean Entrance"

A direction to an actor that neither he nor his shadow should be visible to the camera before he makes his entrance to the scene.

"Clear Yourself"

A direction to an actor in front of the camera to make sure that he is clearly in view of the lens and is not covered by an object or another actor.

CLOSE SHOT

Close Shot

A shot taken with the camera

close, or apparently close, to the subject, which is often a human face filling the field. Also called a close-up, it is abbreviated as C.S. or C.U.

Code and Rating Administration of the Motion Picture Association of America
See AMPTP, No. 2.

Commercial
A short film, usually of one minute, 30 seconds or fifteen seconds, which is specifically made to sell a product.

Commissary
The restaurant on the lot. It can range all the way from a small vending machine arrangement to a full restaurant-dining facility.

Composite Print
The edited film, including all picture, sound and music tracks that have been printed onto one piece of film.

Cone
A cone-shaped lamp used for general, soft-set lighting.

'Confabs'
Conferences.

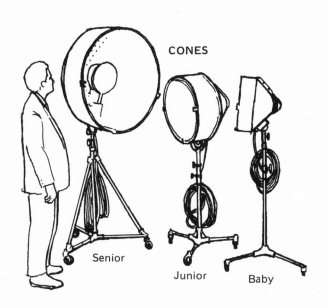

CONES

Senior

Junior

Baby

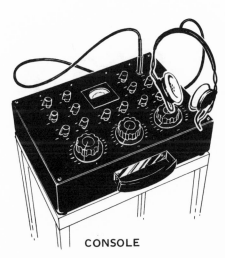

CONSOLE

Console

A control panel for sound re-cording and re-recording which enables input from one or more microphones to be combined and recorded at varied levels. It also makes provision for the mixer (i.e. console operator) to monitor the sound level. Re-recording consoles can have 50 or more controls.

Construction Department

See Carpenter Shop.

Contract Player

An actor under contract to a studio or producer.

Contract to U.I.
Could either be an actor who has a contract with Universal International or who is collecting unemployment insurance.

Contrast Glass
The monacle-like, dark glass eyepiece that the director of photography holds up to one eye while lighting the set in order to check the contrast level of the lighting.

CONTRAST GLASS

Cook, Cookie
May be a wire-framed fabric or a plastic or plywood sheet which is perforated with a pattern of leaves, branches or flowers and set up in front of a light to cast a shadow on flat surfaces. Sometimes opaque or translucent like a scrim. From the Greek word *kukaloris* which means breaking up of light.

Copter Mount
A camera mount, for use in helicopter aerial shots, that isolates the camera from the vibrations of the helicopter. The trade name is Tyler Mount.

COOKIE

Costume Department
See Wardrobe.

Costume Designer
The person who designs and sees

to the production of costumes—
both period and contemporary—
for a film.

"Counter"

A direction to an actor, usually
involving a physical move that
will allow more of the actor to
be seen on camera or will allow
room for another actor or object
in the shot being filmed.

Cover

To photograph a scene, or parts
of a scene, from many different
angles. See Coverage.

Coverage

The entire collection of individu-
al shots, angles and set-ups that
comprise all of the film necessary
to make a complete story.

Covering

When one actor gets between
another actor and the lens or the
other actor's key light, the direc-
tor will say, "You're covering".

Cover Set

The set that will be used for
shooting in case the exterior
scene being worked on is inter-
rupted by adverse weather condi-
tions.

Cover Shot

A part of the film shot to provide transition material from one scene to another or a part of a scene to another part of the same scene. Also, additional footage shot in case the first footage shot doesn't work. Also called 'insurance'.

Crane

See Camera Boom.

Credit Titles

The titles naming the actors in a film and the technicians who made the film.

Critics

Persons in the employ of the various news media who have the job of viewing motion pictures and television and reporting their opinions of the products to their readers. Also called reviewers.

Cross Lighting

Intermediate in its direction—

Camera

CROSS LIGHTING

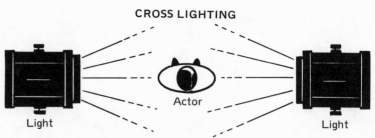

Light Actor Light

between front lighting and back lighting.

Cue

The signal to an actor in the film to commence his part of the dialogue or action. This cue could be an action by another actor, the ending of a piece of dialogue, a signal from the director or a cue light. See Hand Cue, Voice Cue.

Cue Cards

See Idiot Cards.

Cue Light

A small bulb which can be turned on and off by the director or assistant director and which is placed out of the view of the camera but in view of the actor to be cued. The cue light avoids verbal cueing of actors.

CUP BLOCK

Cup Blocks

Used under furniture and light stands to prevent their movement. Also frequently used by cast and crew as ashtrays, although this is not their intended use.

"Cut"

The order given by the director of the film when the action in a shot is completed to indicate

that the camera and sound are to be shut off.

Cut

An instant transition from one shot to another. The cut indicates no time lapse.

"Cut and Hold"

Order from the director for the action to stop but for the actors to hold their positions. The director might want to check lighting, positions, or set up further overlap action.

Cut Away

See Cut to...

Cut Back

To quickly change the image on the film from the present scene to one that has already been viewed. This cut is made without any transition.

Cutting on the Action

Using a large action by an actor in the film as a point in which to cut in closer or further away from the person.

Cutting Room

The place in which the tools of the film editor, e.g. movieola, etc., are housed and where the

film will be put together in story continuity. The cutting room is usually at the studio but may be at an independent location, separate from the studio lot.

Cut to...
To quickly change the image on the film from the present scene to another, with no transition.

Cyc, Cyclorama
See Backing.

Dailies

The positive prints—delivered daily from the laboratory—of the negative film exposed the preceding day.

Day for Night

An exterior scene that takes place at night but is filmed during the day—usually for economic reasons. The use of a filter on the camera creates the nighttime effect.

Day Player

An actor working on a film or television show for only one day. Also referred to as a bit player or an actor 'on a daily'.

D.B.A.

Doing Business As. Used in a contract to indicate an additional name used by the same organization or individual.

Decibel Meter

A meter used to indicate volume of sound.

Depth of Focus

The area within which objects placed at various distances in front of the lens will remain in sharp focus.

DGA—Directors Guild of America

The professional guild that negotiates minimum salaries and working conditions for directors, unit production managers and assistant directors in film, live television, tape, radio, theatrical and non-theatrical film, as well as for associate directors, stage managers and production assistants in live television and tape. Bi-monthly publication: *Action Magazine.* Yearly awards given for outstanding directorial achievement in televison and feature films.

Directors Guild
of America

DGA—Producers Apprentice Program

See AMPTP, No. 5.

Dialogue

Lines which the actors usually rehearse from a script.

Dialogue Coach or Dialogue Director

The person on the set who is responsible for assisting the actors with the learning of their lines during the making of a film. May also assist with some pre-shooting direction of dialogue.

Diffusers

Pieces of diffusing material which are placed in front of the studio lights to soften them.

Dimmer

A control used to vary the intensity of a studio light.

Director

The person who controls the action and dialogue in front of the camera and who is responsible for realizing the intentions of the script and the producer.

DIFFUSER

Director of Photography

See Cinematographer.

Directory

The Academy Players Directory. Lists by photograph the various categories of players in Hollywood, and their representatives.

Dissolve

An optical effect between two shots in which the second shot begins to appear as the first shot gradually disappears.

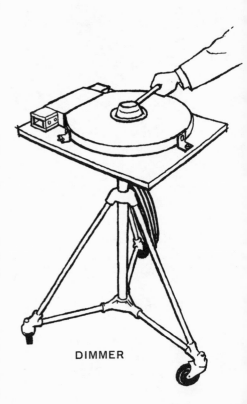

Documentary

A film which presents a real story, shot on the actual locations. Also, a style of filming in which the effect of reality is created by the way in which

DIMMER

camera, sound and location are used.

Dolly

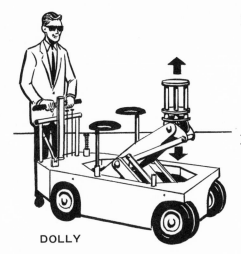

DOLLY

A wheeled vehicle to carry the camera and camera operator. The dolly can usually be pushed and directionally operated by one man, called the dolly grip.

Dollying

The movement of the camera during a shot by the use of a wheeled vehicle that accommodates the camera and camera operator. Sometimes referred to as tracking or trucking.

Dolly Shot

See Follow Shot.

"Don't Block the Key"

Direction to an actor to move because he or she is leaning in one direction or the other and casting a shadow on another actor by blocking his key light.

DOT

Dot

A small, circular scrim, from 4" to 6 or 8" across.

Double

Can be an extra who stands in for the actor during set lighting, or can be a stunt double who replaces the actor in the scene

during the fight, earthquake, motorcycle ride, car crash, parachute jump, etc.

Double Broad
See Broad.

Double System Sound Recording
Sound which is recorded separately from the picture.

Drapery Department
Responsible for making all curtains and drapes necessary for set decoration. Some departments also do upholstering and any other special work that may be required by the nature of the script, such as special period, fantasy or science fiction decor.

"Dress Off"
A direction to an actor before the camera to use a particular object or person as his mark or position in the shot; e.g. "Dress off the corner of the desk."

"Dress the Set"
An order to place the many objects (e.g. lamps, ashtrays, flowers, pictures) about a set to give it the appearance of reality.

Drift
When an actor, almost unnotice-

ably (until it's too late), moves out of his position. Can also be a direction to drift in a certain way, meaning to do it slowly and evenly.

Dry Run

Usually the last rehearsal before shooting. A dry run includes everything but rolling the film through the camera.

Dual Role

The playing of more than one part by the same actor in the same film.

Dubbing

Recording a voice in synchronization with a film image. The voice may or may not be that of the orginal actor or language used when the film was made. Dubbing is usually accomplished by means of film loops—short sections of picture and dialogue in composite print form. The actor uses the image and the sound track playback as a guide to synchronize lip movement of the image with the new sound recording. Usually used to correct originally poor sound recording, artistically unacceptable performances or possible dialogue errors. Also used for post-filming recording of songs and foreign language versions of the film.

Dulling Spray
An aerosol spray that leaves a dull film on any surface that might be causing glare in the camera lens.

Duplicating Department
The department where all the scripts are run on mimeograph or multilith machines. Some departments with more sophisticated duplicating equipment also print studio and production company letterheads and all forms necessary to the operational functions of a film studio.

Dynalens
A trade name assigned to a lens with the ability to shoot film from an unsteady platform. The lens itself compensates for the motion of the camera platform so that the image being filmed is steady.

DYNALENS

Editor

The person who is responsible for assembling the raw material of a film (all footage filmed) and composing it into a coherent whole. In many instances a creative editor can save or, at minimum, enhance the final version of the film.

Editorial Department

The department where all the bits and pieces of film that were filmed are put together into a coherent order, sometimes with the assistance of the director and/or the producer.

Electric Department

Responsible for the maintenance and supply of all electrical equipment (e.g. lamps, cables, etc.) for filming.

Electrician

The person responsible for the placing and adjusting of lights as well as getting the supply of electricity to them. See Gaffer.

'Emmy'
The award statuette presented by the Academy of Televison Arts and Sciences for creative and technical achievement in the television industry.

Enlargement
See Blow Up.

Equity
See AEA.

'EMMY'

Establishing Shot
A long shot, usually an exterior, which establishes the where-abouts (i.e. the geography) of the scene.

Exclusive Contract
A contract which states that a person can perform services for only the individual or company with whom he is contracted.

'Exex'
Executives.

Exhibitor
1. The man or company that owns the theatre or drive-in, or chain of either, in which films may be seen. 2. The theatre or drive-in where films may be seen.

'Exhibs'
Exhibitors.

Exploitation
 Used to describe the advertising campaign for a film or television series.

Exploitation Film
 Usually an inexpensive film which is made for a specific audience interest, such as in horror, motorcycles or psycho, and released for a quick run in local theatres.

Ext.
 Exterior. Any part of the film shot outside: city street, stadium, desert, forest, mountain-top. Some of these locations can be re-created on the studio soundstage, but they are still referred to in the script as exterior.

Extra
 A person employed as a background player, such as one of a crowd in a street scene. See Atmosphere.

Extreme Close-Up
 Very tight on the face of the actor. The bottom and top of the frame may go from above the chin to below the hairline. Can also be a shot of an object rather than a person.

EXTREME CLOSE-UP

F

Fade Out, Fade In

An effect in which the picture gradually fades to blackness (fade out) or appears out of blackness (fade in). Used to denote the passage of time or the ending of a story.

False Move

An unplanned motion made by an actor before making a move that has been planned. A false move by an actor can create problems by setting the dolly grip in motion with the dolly and camera because he thought the move made by the actor was a cue to move the camera.

Fast Motion

Filming at slower-than-standard speed, then projecting at standard speed to make the action appear faster than normal. Also creates an old-time, silent movie effect.

Featured Part

Not important enough for a star,

but large enough to merit special attention. Usually performed by an actor who is fairly well-known to the audience.

Feedback
A situation in which the output from one sound source is playing into another sound source, causing a frequency squeal or loud hum.

FIFTY-FIFTY

'Feedback'
A term usually used to describe complaints or squawks from the front office.

'Fest'
A showing of a group of films. A festival. See Film Festival.

Fifty-fifty
Usually a camera angle or shot of two actors who, facing each other, share the lens equally. Also called a two shot or a two.

Fill Light
General set lighting used to soften the contrast of the key lighting.

Film Clip
A short piece of film. See Stock Footage.

Film Festival

A showing of a group of films, either in recognition of the works of a specific person or a general grouping of the films of a particular year, type or subject.

Film Loader

Member of the camera team—sometimes the assistant cameraman—who loads unexposed film into magazines and unloads exposed film into cans.

Fire Department

Each studio usually has its own fire department; not necessarily made up of fire engines, but personnel who are trained in fire control and the maintenance of fire equipment such as hoses and extinguishers.

First Aid Department

Most major studios have a first aid department on the lot, usually manned by a trained nurse and assistants.

'First Man Through the Door'

The leading 'heavy'. See Heavy.

First Run

The first time a film is released to theatres for exhibition.

'First Team'
>The actors who will be doing the scene in front of the camera, as opposed to their stand-ins. The call from the set, "First team," means the actors should return to the set because the preparations for shooting are completed.

FISHPOLE BOOM

Fishpole Boom
>A lightweight, portable hand-held pole which is used to support a microphone during filming in difficult locations.

Fitting Fee
>Additional pay to the actor when he's on a wardrobe fitting. See Wardrobe Call.

Film Industry
Workshops, Inc.

FIWI—Film Industry Workshops, Inc.
>A non-profit, California chartered educational workshop for the creative crafts, e.g. directing, acting, in the motion picture industry. The Workshop is supported by tuition and grants, and membership is by audition only. FIWI is pronounced FEE—WEE. Monthly publication: *FIWI News.*

'Flack'
>Publicist. Probably a description

of his job, which is to attract attention, much like anti-aircraft fire, which is also called 'flack', attracts attention.

Flag

A miniature gobo of plywood or cloth on a metal frame which is usually set on a century stand.

Flare

When some object or light on the set is reflecting unwanted light directly into the lens.

FLAG

Flashback

A part of the film story which deals with an earlier period of time, relative to the story.

'Flesh Peddler'

A rather negative term which is used when someone in the business, other than an agent, is feeling sour about agents.

'Flick'

A term for motion picture.

Flip Over

An optical effect in which the picture appears to flip vertically or horizontally.

'Flub'

When an actor has made a mis-

take with the words—'flubbed his line'.

Fluid Head

A motion picture camera mount which provides smooth movement for the camera through the use of a flywheel which is encased in an oil-filled container in the head itself.

Focus

The sharpness of the image coming through the lens.

Fog Maker

By use of special liquids the fog maker can create the effects of fog, smoke, haze and mist. By the use of a different liquid it can also be used to dispell unwanted fog. A fog maker can be either a small, hand-held machine or a large machine mounted on a cart.

Follow Focus

A change in camera focus during a scene in order to hold focus on an actor moving toward or away from the camera. Usually the job of the first assistant cameraman.

Follow Shots

Shots in which the camera moves around to follow the action in the scene. See Dollying, Trucking.

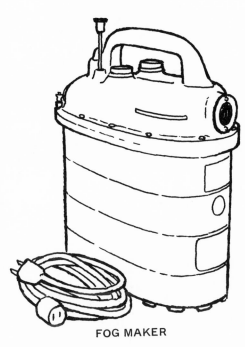

FOG MAKER

FRAME

Footage

A unit of measure used for film.

Footage Counter

Located on the camera to keep track of the amount of film that has been exposed.

Academy

Forced Coverage

When a mistake is made during the filming of a scene, rather than re-shoot the scene from the beginning, the director might think it more economical to shoot the rest of the scene, then get the additional coverage—perhaps a close-up—necessary to bridge the gap caused by the forced cut.

Cinemascope

Foreign Department

The liason for production, publicity, promotion and/or sales with the overseas affiliates of the studio and other foreign studios.

Wide Screen

Four-Walled Set

A set that has four walls instead of the usual three. The four walls completely enclose the area of action, but may be moveable to allow the movement of lights and camera while filming.

TV Safe Action

Frame *n*

One photograph of the many on a roll of exposed film. Frame size

will vary according to the format being shot—Academy, Cinemascope, Techniscope, etc.

Frame *vb*

To adjust the camera and lens so that the picture to be taken is bordered ('framed') as desired.

Frames Per Second

Since 35mm film runs through the camera at a normal speed of 24 frames per second (90 feet), if more frames are run per second, the action of the subject is slowed down when projected at normal speed. If fewer than 24 frames are run, the action appears to speed up when projected at normal speed.

Framing

See Lining Up.

Freelancer

A person not under contract to any specific producer or studio.

"Freeze"

An order to actors to stop action but hold their positions. In a film in which other actors or objects suddenly appear, i.e. 'pop in', on the screen, the actors in the scene will be told to freeze. The person or object is then placed in position, the order for "action"

is given, and the scene resumes.
In the cutting, the intermediate
film of the entrance of the actor
or the placement of the object
will be cut out.

Friction Head
A motion picture camera mount
which, by the friction of one
metal component in the head
against another, provides smooth
movement for the camera.

"From the Top"
An order from the director to
start the scene from the begin-
ning.

Front Lighting
The main lighting of a set, direct-
ed toward the set from behind
and beside the camera.

'Front Office'
Usually used to refer to the place
where all important decisions are
to be made, such as the office of
studio management or the office
of the producer.

Front Projection
A system in which the image to
be photographed with the actors
is reflected off a two-way mirror
onto a screen in front of which
the actors will work. The com-
bined projected image and live

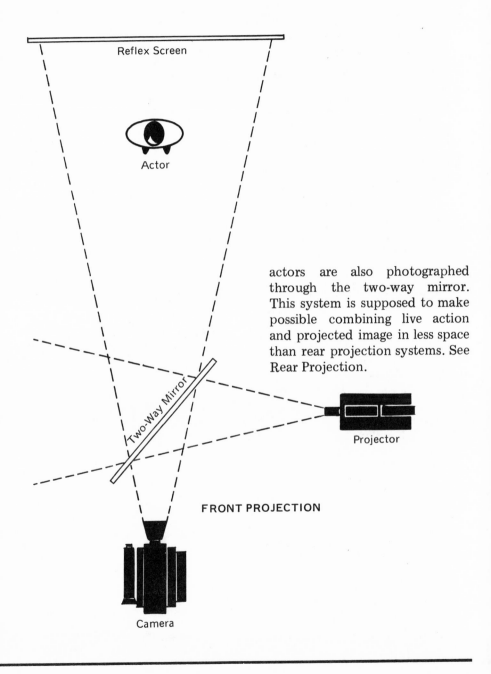

Reflex Screen

Actor

Two-Way Mirror

actors are also photographed through the two-way mirror. This system is supposed to make possible combining live action and projected image in less space than rear projection systems. See Rear Projection.

Projector

FRONT PROJECTION

Camera

G

Gaffer

The chief electrician who is responsible under the first cameraman for the lighting of the sets. See Electrician.

Geared Head

A unit, on which the camera is mounted, which can be mounted on a dolly or crane and either panned (in a horizontal movement) or tilted (in a vertical movement), allowing the camera to follow the action. The two movements are carried out by gears which are operated by crank handles.

GEARED HEAD

Gen

Generator truck used to provide electrical power when the film unit is on location or supply additional standby power at a studio. Also called a jenny.

"Give Me a Level"

A request to the actors from the sound mixer to give him a sample

of how loudly or softly they will speak their lines in a scene so that he may prepare his equipment for recording the dialogue.

Glossy

A photograph on glossy finish paper. Usually refers to 8" x 10" photos of actors which they use to give to agents, casting directors, producers, directors and, hopefully, fans who want a likeness of the actors.

Gobo

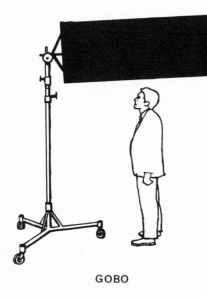

GOBO

A wooden screen which is painted black. Used to block off light from one or more studio lamps lighting a set to prevent spill-over of light into the camera lens or areas of the set where it isn't wanted. Usually mounted on adjustable stands. Gobos come in many sizes and shapes.

Golden Time

'Super overtime'. Check the ruling with specific guilds and unions. If the term is used on a working set in a negative way in regard to an actor because he was responsible for the company going into golden time, he may never work for the company again.

Goon Stand

A large version of the century

stand. Used to hold flags and cutters to prevent light from illuminating an area of the set where it's not wanted.

Green Department

Responsible for supplying the trees, bushes, flowers (in pots and out), grass and all growing things, both real and plastic.

Grip

The person on the set who has charge of moving and setting up camera tracks, walls and the like; whatever takes a strong 'grip'.

Grip Chain

A lightweight link chain used for many jobs by the grip department. On the set it is often used around the base of the leg of a chair or couch, which is on casters, to keep it from rolling.

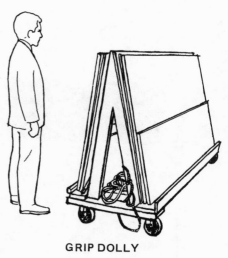

GRIP DOLLY

Guarantee

Used in regard to how much time of employment an actor or director is guaranteed on a particular job, or under a particular contract.

Guards

See Security.

H

Hailer
See Bullhorn.

Hairdresser
A hairstyling specialist for film. One hairdresser might work with both male and female hairstyles.

Hairdressing Department
Responsible for the actors' and actresses' hair needs, real or wig.

Half-Load
Not a level of inebriation, but the quantity of powder placed in the shell of a blank cartridge. The amount of powder varies according to the purpose to which the bullet is put and the location—exterior or interior.

Hand Cue
Usually given by the director or the assistant to indicate the moment for an actor's entrance or a specific piece of action.

Hand-Held

Filming with a lightweight camera such as the Arriflex, Eclair or Beaulieu, any of which can be held in the hands of the camera operator while filming, as opposed to being mounted on a gear head or tripod. Provides greater flexibility.

Hard Ticket

See Road Show.

Headroom

The space between the top of the object in the picture and the top edge of the frame.

"Heads Up!"

A loud call on the set to warn people that some large, and maybe heavy, object such as a sound boom, camera boom or grip dolly is being moved. It should alert one and all to look around so that the object won't strike them.

Heavy

The antagonist. The person who does the 'bad things'. An actor who is thought of as 'ugly' is usually cast in this stereotype part. See 'First Man Through the Door'.

Helmer

The person who handles the

helm—guides the production of a film. Usually refers to the director or sometimes the producer.

Hiatus

Time off from shooting for a televison series or film. Usually an extended period of weeks.

HIGH HAT

High Hat

A small metal tripod of fixed height which can be attached to the floor to hold it in a secure position. Used to mount the camera for low angle shots.

High Key Lighting

Lighting that provides an effect of brightness in a scene.

High Lighting

Additional lighting applied to an area to provide dimension and depth or sculpturing.

High Shot

A camera angle which looks down on the subject.

Hip Pocket Client

An agent's term to denote a client he represents who is not signed to a contract.

Hit

As in "Hit the lights" or "Hit the

blowers", meaning turn on the lights or turn on the blowers (stage coolers). To kill is the opposite—to turn off.

"Hit the Mark"
A direction to an actor to move to, or stand right over, his mark.

Hollywood Reporter
A magazine-size newspaper which is published daily with news of the film business. See 'Trades'.

Honey Wagon
Trailer toilets used on location.

Hospital
Many studio lots are equipped with what can only be called a small hospital, which is usually staffed by a trained nurse or doctor.

Hot Set
A set that is fully furnished and decorated (i.e. dressed) for shooting. The description usually indicates that the set shouldn't be walked into or sat on.

Hot Spot
An area in a set in which the lighting is excessively bright.

IJK

International Alliance of
Theatrical Stage
Employees

International Brotherhood
of Electrical Workers

IATSE & MPMO—International Alliance of Theatrical Stage Employees and Moving Picture Machine Operators

Also referred to as the IA. The parent labor union of the people behind the scenes, such as the cameraman, grip, electrician, draper and driver. Consists of approximately a thousand local unions identified with the theatrical, television and motion picture industries. Primary function is to negotiate wages and working conditions for its members. IATSE is pronounced I-YAHT-SEE.

IBEW—International Brotherhood of Electrical Workers

The labor union that negotiates wages and working conditions for all electrical, sound and air conditioning workers in motion picture production.

Idiot Cards

Large cards on which the dialogue is printed for the actor

who can't remember his words. Can also be an expensive piece of electronic machinery, called a Tele-Prompter, which is a rolling reel of paper mounted over, or next to, the camera, on which the dialogue has been typed in large, easy to read lettering. Also called cue cards.

Improvise

To create words and/or action on the spot.

Independent

A person making films who is not employed by a major studio. Also refers to the film itself.

Industrial

A film, sometimes with a story line, which is made to sell a company or its products, either to the employees of the company or to the general public.

Ingenue

An actress who is somewhere between the ages of 16 and 20.

Inked

The ink in the signed contract. Literally signifies that a person has been signed to a contract for employment.

Inky

A 150-watt lamp. Smaller than a baby.

Inky Dink

A miniature lamp, usually of 250 watts, which is primarily used as an eye light. Usually mounted on the front, or side, of the camera to point directly at the face of the subject. Also called an obie.

Insert Shot

An object—usually a piece of printed matter such as a newspaper, or a clock—which is cut into a sequence to help explain the action.

Insurance

See Cover Shot.

Int.

Interior. That part of the film which is shot inside. Can be a living room, bedroom, kitchen, garage, office, operating room, etc. Interiors can either be those sets that are constructed at the studio or actual settings away from the studio. The latter are referred to as location interiors.

Intercut

To change the action back and forth from one scene to another, usually at a fairly rapid pace.

Iris

The opening either in the lens or behind it that admits light to the film. The size of the iris can be controlled by the cameraman.

Jell

The gelatine or colored plastic material used in front of a lamp to change the color of the lighting. Also called gel.

'Juicer'

See Electrician.

Jump Cut

To cut from one shot in the film to another with no transition. Also to move from a long shot to a close-up, and vice versa, with no change in camera angle.

JUNIOR SPOT

Junior Spot

A 1000 or 2000-watt lamp used to place a beam of light on a specific area of the set or actor.

Juvenile

An actor who is somewhere between the ages of 16 and 20.

Key Grip

The man in charge of the grip laborers.

Key Light

The main light used to illuminate a particular subject. See "Don't Block the Key".

"Kill"

As in "Kill the baby," meaning turn off the baby spot light. Same as "Save the baby" or "Save the arcs".

Knock-Down

A portable dressing room made of braced and framed canvas which can be quickly set up and taken down. Strictly temporary.

Knocks

A bad review. See Review.

L

Lab

Generally, the place that develops the raw stock (film) that has been exposed (shot).

Lap Dissolve

See Dissolve.

Leading Man or Woman

Usually between the ages of 25 and 45. Being beautiful or handsome used to be a basic requirement, but good looks are no longer thought necessary.

Lens

A construction of various pieces of glass, cut and ground for specific purposes and encased in a metal tube. Some lenses are fixed, i.e. non-adjustable for focal length. Others, such as the zoom lens, are adjustable. The lens admits light to the film, controlling the field of view that determines the size of the image on the film.

Lenser

The director of photography on a film.

Level

The quantity or degree or measure of sound.

Lighting, types of

Back, Cross, Front, Hot Spot, High Key, Low Key, Top, Front, Flat, etc.

Lighting Equipment

Century, or C, Stand, Christmas Tree, Cookalorous, Diffusers, Flag, Gobo, Goon Stand, Light Meter, Reflector, Scrim, Trombone, etc.

Light Meter

A small, hand-held instrument, used for measuring the amount of light on the set and actors.

Lights, types of

Baby Spot, Broad, Double Broad, Brutes (Arcs), Cone, Inky, Inky-Dink, Junior Spot, Key, Obie, Reflector, Scoop (Sky Pan), Senior, Soft.

Lining Up

Lining up a shot. The cameraman and/or director set up the camera

to cover the desired field of view.
Also referred to as framing.

Limbo

Filming in an area or set that is
not identifiable as a specific loca-
tion. Can be used for close-ups,
inserts, etc.

Lip Sync

A recording session in which the
actor matches his voice to the lip
movements of the image on the
screen.

Location

A place, other than the studio lot
and sound stages, where the film
is being shot.

Location Department

Responsible for knowing how to
find the specific location neces-
sary for a film, how to make the
arrangements for its use and how
to get the film company there.

Logo

The symbol or slogan identifying
a company.

Long Focus Lens

A relative term describing lenses
of longer-than-normal focal
length (telephoto) which give
magnification to the image.

Long Shot

A shot in which the object of interest is, or appears to be, far from the camera. Abbreviated L.S. or LS.

Looks

Specific directions in which the actor will be asked to direct his eyes in order to either match action in a previous shot, prepare the audience for action, or indicate the location of a person or object not in the picture, i.e. off camera.

Loop

1. A slack piece of film to provide play when film is moving through a camera or projector. 2. A scene or piece of a scene on film which has been joined end-to-end (in a loop) so that it will project continuously as a guide for an actor dubbing a voice, or a piece of sound tape containing a sound effect, or music used in re-recording.

Looping

The process of working with film or sound loops in a dubbing session. See Dubbing, Loop.

Lot

Generally refers to the entire property of the studio where filming is done.

Low Key Lighting
Set Lighting which is relatively dark. Many objects in the scene are allowed to fall into semi, or even total, darkness, throwing the lighted areas into stronger contrast.

Low Shot
A camera angle which looks up at the subject.

Magazine

A film container which forms part of the camera or projector. Camera magazines are light-tight; i.e. the film moves through openings which allow no light to enter the unexposed or exposed film in the magazine.

Magnetic Recorder

A tape recorder which uses magnetic tape to record sound, as opposed to an optical recorder (optical track) which reproduces an oscilloscopic image of the sound on film.

Mag Stripe

The application of magnetic particles to one edge of a strip of film so that a magnetic recording can be made on it. This film, with its sprocket holes matching those of the film with images on it, is used to align the specific sound with the picture.

Make-Up Artist

A specialist in make-up for film.

Make-Up Call

The time the actor is to be at the make-up department or the make-up table on the sound stage before beginning his work in front of the camera.

Make-Up Department

The department responsible for the appearance of the actors and actresses, seeing to it that they look their best (or worst, as the case might require) when they go before the camera.

"Mark It"

An order to the camera assistant to drop the clapper stick on the slate board in order to mark sound for the scene when the camera is running at photographing speed. See Slate.

Marks

Used to give actors or the dolly grip a specific reference point for where they should be at a certain time in the scene. These marks can be made with chalk, paper tape, wood or metal tees or triangles, in dirt or on the floor.

Master Shot

Formerly, the entire scene shot in continuity, with the camera placed to encompass all the action. Now, just a portion of the scene, into which other coverage

MAKE-UP TABLE

will be cut, is also accepted as a master shot.

Match

To reproduce actions carried out in another scene or take so that the two can be intercut and positions will match.

Matching Direction

A director's problem of matching the direction of actions in the film, such as entrances from left to right, so that people or vehicles in the film won't appear to have switched direction when other takes are intercut. See Script Supervisor.

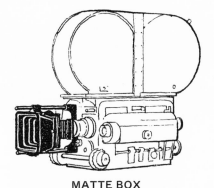

MATTE BOX

Matte

A cut-out, or partial mask, which is placed in front of the lens to prevent part of the film from being exposed. The unexposed portion can be exposed later so that it appears, for instance, that identical twins are in conversation, when actually only one actor is playing both parts.

Matte Box

A frame mounted in front of the camera lens, which is designed to hold the camera mattes used in trick, or special effects, photography, as well as to hold special filters. The matte box is usually combined with a sunshade.

Meal Penalty

The additional sum of money which a production company is responsible for paying an actor when he has worked beyond five and a half hours from his first call of the day, and six hours from his call-back from the first meal break.

Measuring Tape

Used to measure the distance from the lens to the subject in order to accurately determine focus.

Medium Close Shot—MCS

A picture of the subject somewhere between a close-up and a medium shot.

Medium Long Shot—MLS

A picture of the subject somewhere between a medium shot and a long shot.

Medium Shot—MS

Showing a person at full, or nearly full, height.

Megaphone

A large, cone-shaped tube which is held to the mouth to amplify the voice.

'Megger'
> The director of the film. In olden times he used to carry a megaphone.

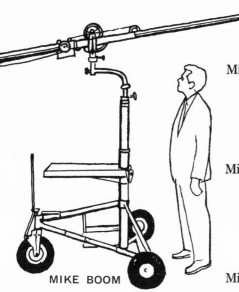

MIKE BOOM

Microphone Boom, Mike Boom
> Used to hold the microphone over the set and turn it in any direction to best pick up sound and dialogue as required.

Microphone Shadow
> The shadow cast by the microphone on some part of the set within the field of view of the camera. If it's in the picture, it's a no-no.

Mike
> Microphone. The instrument used to pick up the sound and dialogue on the set. Microphones, in the form of cordless transmitters, can also be worn by the actors.

Mikeman
> See Boom Man.

Mill
> See Carpenter Shop.

Mimeograph Department
> See Duplicating Department.

Miniatures

Reproductions of objects in smaller sizes, ranging from battleships (to re-create sea battles in the studio tank) to an entire city (to be burned or buried beneath an earthquake). Usually the job of the special effects department.

Minimums, Minimum Scale

The daily or weekly wage scale established by agreement between the various guilds and unions, and the producers.

Mixer

The senior member of the sound recording crew who is in charge of the balance and control of the dialogue, music or sound effects to be recorded.

Mixing

The job of combining a number of separate sound tracks onto a single track.

Mock-Up

A facsimile, usually life-size, of an object in the film. It might be the interior of an airplane, car, space vehicle or boat, but is sometimes just an exterior shell which will be blown up, or otherwise destroyed, during the scene.

Monkey Fist, Paw

An intricate piece of rope work

which is woven on the end of a line and hung on the end of a sound or camera boom so that people will, hopefully, notice it and not disturb sound or camera by walking into the boom.

Monochrome
Black and white film.

Montage
A series of pictures which flow, dissolve, or sometimes cut, from one to the other. Can be used to show advance or reversal of time, change of location.

M.O.S.
A portion of a picture—a scene—which is being filmed without sound being recorded. The initials supposedly came from the European director who, not being able to pronounce his Ws, said "Mit out sound."

Motion Picture Relief Fund—MPRF
An organization devoted to assisting needy members of the motion picture business. Supported by independent contributions or through payroll deductions.

Moving Shot
Filming from a moving object such as an airplane or car.

Moviola

The trade name of a particular kind of mobile, motor-driven film-viewing machine which is used in the editing of film. The name is often applied to any machine used in editing.

MPMO

Motion Picture Machine Operators. See IATSE & MPMO.

Multicam

The making of a film with more than one camera covering the action at the same time.

Music Department

Responsible for supervising and/or supplying the music used in films.

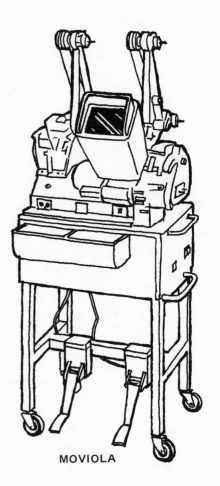

MOVIOLA

Narration
A voice on the soundtrack of the film which describes the action or tells the story.

NC—Noiseless Camera
Designed and built by the Mitchell Camera Corporation. With the advances made in hypersensitive sound systems, today the NC is primarily used for filming exteriors.

NCOMP—National Catholic Office for Motion Pictures.
The arm of the Catholic Church which rates the moral standards of films, for the benefit of its members.

Negative
Either raw stock which is designed for negative images, the negative image itself, negative raw stock which has been exposed but not processed, or processed film.

Negative Cost
The amount of money it takes to make a film.

NET—National Educational Television
A network of cooperative, educational television stations. Non-commercial.

Net
Network. A group of television and/or radio stations which are owned by or contractually affiliated with the same company.

Net
Income after all expenses.

N.G.
No good. The term is, unhappily, applied to performances or the record of shots on the camera report, e.g. N.G. sound, N.G. action.

Night Filter
A red filter which is used in the camera to produce night effects on black and white film when filming during the day.

Non-Exclusive Contract
An agreement in which the person, actor, director or writer is guaranteed a certain number of segments on a televison series, or

a number of feature films per year, by the contract company, but is also allowed to work outside the contract for other companies.

Non-Sync
See Wild Recording.

Non-Theatrical Film
Movies which are not intended for showing in commercial theatres but are training films, usually for schools, churches and businesses.

No Print
A note which is placed on the camera report to indicate that the take is not to be printed by the lab.

Normal Focus Lens
In 35mm, 2 inches; 16mm, 1 inch. Both 35mm and 16mm refer to the width of the film.

Nudie
A film that depends on arousing the audience's prurient interest for its appeal through the exposure of large expanses of the uncovered human anatomy, engaged in activities that are usually considered personal. Also referred to as Skin Flicks.

Obie

A small lamp, usually about 250 watts, which is mounted on the front or side of the camera blimp or gear head so that the illumination is directly on the actor's face. This front lighting seems to lessen the shadowing of wrinkles and age lines, and generally enhances the appearance.

'On a Bell'

The warning bell or horn, or a call from the assistant director to be quiet on the set. No walking or talking. Usually accompanied by a red light at all of the entrances to the stage or working area.

'On a Daily'

See Day Player.

One-Liner

See Zinger.

O.S.

Off Screen. A voice or sound that comes from off screen, out of camera range.

'Oscar'

The award statuette which is presented at the annual Academy Awards for outstanding achievement in the motion picture industry.

'OSCAR'

Outs, Out Takes

Rejected portions of a shot, or scenes which aren't in the completed version of the film.

Overhead

The cost of running and maintaining a studio, all of its departments, employees and equipment.

Overlap

When the director asks an actor to overlap, he shouldn't wait for the other actor to complete his line before starting his. When asked not to overlap, he should leave a clear space between his lines and those of the other actor. Usually comes up when an actor is in a single, with the other actor feeding his lines from off camera.

Over Shoulder

A shot of another person or object, which usually includes the head and shoulder of the actor in the foreground who may be facing toward or away from the camera.

P

P.A.

A personal appearance tour which is usually made by people connected with a film (such as the actors or director) to attract public interest in the product. Appearances will be on television and radio, at dinners, press interviews and supermarket openings.

Package

To put together a complete, or nearly complete, production. Usually, having acquired the rights to a property, the producer then seeks agreements with stars who will work in the film and who can assure some kind of financial commitment from banks, studios or independent backers to make the movie.

'Pact'

A contract.

'Pactee'

A person—actor, writer or director—who is under contract to a producer, studio, agent or film.

Paddle Plug

The type of plug attached to most lamps which are used in motion pictures for set lighting.

Pads

1. Stunt Pads. Like over-stuffed mattresses, usually about 4' x 6' and 8" to 10" thick. Used by stunt people and actors to soften the impact of a fall. 2. Knee and Elbow Pads. Pads which are just large enough to cover the knee or elbow and are held in place with elastic bands around the arm or leg. When the pads can be concealed under clothing, they are used by actors and stunt people to soften the impact of a fall.

Paint Department

Responsible for set painting and decoration. The paint department can, on call, make almost anything look new, or terribly old.

PAN

Pan

Horizontal movement of the camera. Sometimes the word is used generally to describe camera movement in almost any direction.

'Pan'

A bad review. "You made a dull film" is a pan. "The critics panned the film." See Review.

Parallax

The difference between the image seen through the viewfinder, which is mounted on the camera, and the image which is seen through the lens of the camera itself. In framing a picture, the camera operator must allow for this difference so he won't cut off any area of the image.

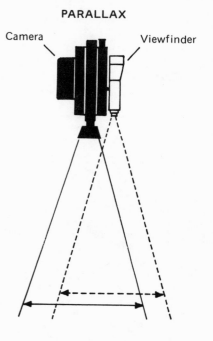

PARALLAX

Camera Viewfinder

Parallel

A platform, constructed of sections of steel pipe which are clamped together, which can be set up in the studio or on location to raise the camera and crew or lights into a position for high-angle shots.

P.D.

Public Domain. Written material, such as books and music, may be used commercially without payment of royalties to the author or his estate if the author's copyright has expired.

Penned by . . .

The writer of the script or music.

A Percentage of the Gross

A part of every dollar earned by the film before expenses are paid.

A Percentage of the Net

A part of the dollar that is left after expenses are paid. The odds on getting any money this way are very long.

Per Diem

Additional money paid to an employee for living expenses, hotels, meals and transportation when he is out of town or the country.

Persistence of Vision

The only thing that makes the entire film business possible. The brain retains an image for a moment after seeing it. If the image is repeated rapidly enough, it will appear to be continuous.

Personality Test

A piece of film in which someone, usually off camera, tries to make the actor being tested feel relaxed and at ease by asking questions on a variety of subjects, mostly about the actor. Something like an interview by Hitler's Gestapo.

Pic

Motion Picture

"Pick it Up!"

A direction to the actor to say the words and carry out the action more quickly. Literally, it

can also be a direction to pick up
some object.

"Pick-Up"
An order from the director to
start the scene from the place
where it was cut, or from where
it was last started. The director
may designate a specific starting
point; e.g. "Pick up from..."

Pix
Motion pictures.

Playback
1. The playing of recorded music
during rehearsal of a singing or
dancing sequence so that a live
orchestra is not used on the
soundstage. 2. The playing of re-
corded music during filming of a
sequence so that the final music
can be recorded later under opti-
mum conditions. 3. The imme-
diate reproduction of a sound
and/or image on tape or film.

Players Directory
See Directory.

Plot
The story line of a script.

Plumbing Department
Considering how much plumbing
there is on a major lot, it's no
wonder a plumbing department

is needed—not only for the realities of daily living, but also to make the sink on the film set practical. See Practical.

Post
A position with a company.

POWER PACK

POWER BELT

P.O.V.
Point of View. A camera angle which shows what someone in the film is seeing.

Powderman
See Special Effects.

Power Pack
A relatively lightweight power supply for a hand-held camera and/or recording unit. There are also Power Belts and Battery Packs.

Practical
The description of something on a film set that works just as it does in reality. The gas stove cooks, the sink drains, the door opens, the lamp lights.

Premiere
The first public showing of a theatrical film or television show.

Pre-Scoring
Recording music or other sounds

before filming the picture that goes with it.

Prexy

President of the company.

"Print"

Order from the director when a take is completed to send it to the laboratory for developing. This film will be viewed with other prints in the dailies. See Dailies.

Process Projection

The projection of an image, such as a waterfall or city street, on a translucent screen which is placed behind the actors. Also called Back Projection, Rear Projection, and Process.

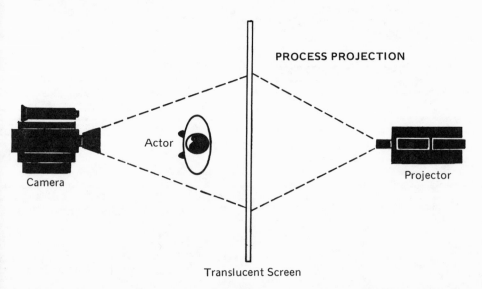

PROCESS PROJECTION

Actor

Camera

Projector

Translucent Screen

Producer
The person who carries the ultimate responsibility for the original shaping and final result of a film.

Production
The process involved in preparing and making all the original materials that are the basis for the finished film.

Production Department
Determines the cost breakdowns and handles the preparation for the shooting of scripts the studio hopes to film.

Production Manager
The person responsible for the day-to-day details of the production company—before, during and after filming, until completion.

Production Unit
A self-contained group which consists of the director, camera crew, sound crew, electricians and all the people necessary to the film.

Projection Department
Operates and maintains all equipment on the lot that is necessary for projecting film.

Projectionist
The person who runs projection equipment at studios and in theatres.

Projector
Film projector. The machine used to enlarge the image of the film and project it to a reflective screen where it can be viewed. Uses a powerful lamp behind the film, a lens in front of the film and a mechanism which moves the film between the two at a regulated speed.

'Promo'
Promotion. Refers to some form of publicity used to promote the sale of a motion picture, a television program, an individual talent or company.

Prop Box
They come in various sizes and shapes, but most are on wheels. The many compartments, slots and drawers contain the innumerable items the prop man may have decided are essential for the film, from needles and thread to liquor bottles.

Property
The story, book or magazine article which will be written into a screenplay from which the film will be made.

Property Department
Responsible for the many props that will be necessary for use in a film, and seeing to it that they're on the set when necessary.

Prop Man
The person who finds, secures and sees to it that props are where they should be when they should be there—from hand guns to pots and pans.

Props, Properties
The article to be used in the film, from furniture to cigarette lighters.

Publicist
The person—free-lance or studio employee—whose job it is to get out interesting information to newspapers, magazines and news-services about the film and the people connected with it, often well before the film is in production. Many people in the film business employ a personal 'pub' to keep them in the public eye.

Publicity
Bringing the product and people involved with it to notice, both in the business and to the public, through the use of billboards, posters, newspaper interviews, advertising, radio and television

appearances, and coverage in all news media.

Publicity Department

The people who set up the advertising, art, merchandising, and all aspects of publicizing for films, stars and other personalities connected with the product.

Push-Over Wipe

The image on the screen moves horizontally across the screen, seeming to be propelled by the image following it; somewhat like changing slides in a projector. Also can be done with the image remaining in position but the vertical line bringing the new image into view behind it.

Quarter Load
See Half-Load.

Quartz Lights
Light provided by a filament of tungsten inside a quartz container in which there is an amount of halogen.

Rackover
The side-to-side movement of the camera inside the blimp. In order to allow direct viewing through the lens, the camera must be racked over (i.e. moved) to the right. For shooting, the camera must be racked over to the left, behind the lens.

Rain Cluster
A set of sprinklers which can hang overhead to simulate the effect of rain.

Ranch
Studio Ranch. An exterior location, usually away from the main studio property, which is used

for filming outdoor scenes. Also, independent ranches used for filming.

Rating
Usually refers to various systems that supposedly measure the quantity of audience that watches a particular show on television. Also refers to the Motion Picture Rating which is used to determine, based on the content of a film, which age groups will be allowed to see the film, accompanied or unaccompanied by an adult.

Raves
Those reviews that state the film or television show is outstandingly good. See Reviews.

Raw Stock
Film which has not been exposed.

Reaction Shot
A shot which is inserted in a scene to show the effect of words or action on other participants in the scene.

Reader
A person who is employed to read materials—books, articles, treatments, screenplays—which have been submitted to studios

and producers as possibilities for films.

Reading

Audition. An opportunity for an actor to read a part in a script for the people who will be making the movie, commercial or television show, in hopes of getting the job. Sometimes the actor is allowed time to prepare with the script in the outer office; sometimes not. In any event, a performance is necessary to get the job.

Recording

The process of making a visual or audible record on film or tape.

Recording Stage

A sound stage which is used for recording sound or music. Most recording stages are equipped with facilities to project film so that the sound can be synchronized with the image.

Red Light

A red light bulb, or rotating beacon, which is usually placed both inside the sound stage and outside the soundstage door to indicate that filming is going on and, therefore, silence is necessary. Used in conjunction with the bell and horn.

Reel of Film

The amount of film which will project for ten minutes: 900 feet of 35mm or 360 feet of 16mm. Standard reels will hold up to 1,000 feet of 35mm and 400 feet of 16mm.

Reflector

A surface coated with a silver material which is used to reflect light. For exterior filming, reflectors are often used to direct sunlight on some part of the scene. For interior lighting, reflectors are a part of the studio lamp used to increase the amount of illumination from the bulb.

Reflex Viewfinder

A unit which allows the camera operator to view the action directly through the lens while the camera is filming.

Release Negative

A complete negative which is specifically prepared for making release prints, including picture, dialogue, effects and music tracks.

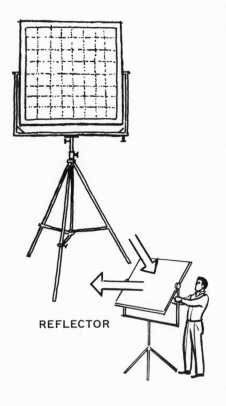

REFLECTOR

Release Print

A composite print which is made for distribution to theatres after the trial composite or sample print has been approved.

Releaser

Distributor. The company which contracts with the producer of a film to release it, meaning to distribute the film to theatres for showing.

"Re-Load!"

The call from either camera or sound when they have run out of film or tape or are so close to the end of their supply that they don't have enough for another take.

Remake

A new edition of a film previously produced.

'Rep'

Representative, Representation. "He is my rep" or "I'm repped by..."

Re-Release

A film being exhibited for another time, after having already been in general release.

Re-Run

A re-play of a film or televison show.

Research Department

Composed of the people who authenticate the articles, objects,

costumes and events in a film—
hopefully, before it's made.

Reserved Seat Engagement
See Road Show.

Residuals
Additional pay to the talent for
re-use of a television show. Simi-
lar to royalties for authors.

Resolution, Resolving Power
The ability of a lens or film to
pick up and show fine detail.

Resume
Detailed listing of a person's
training and experience.

Re-Take
Can be the re-shooting of a scene
just filmed, or one completed
some time previously.

Reverse, Reverse Angle
The opposite camera angle of
one just completed, to show the
other side of the picture.

Reviews
Those articles in newspapers and
magazines (also on television
news) that purport to be an opin-
ion of the film or television
show—the opinion being that of

the reviewer. In many instances the reviewer seems also to go further with a crystal ball and states who should get credit for the camera work, the performances by the actors, the direction, etc., all without having been on the set to see who was really responsible for the work on the screen.

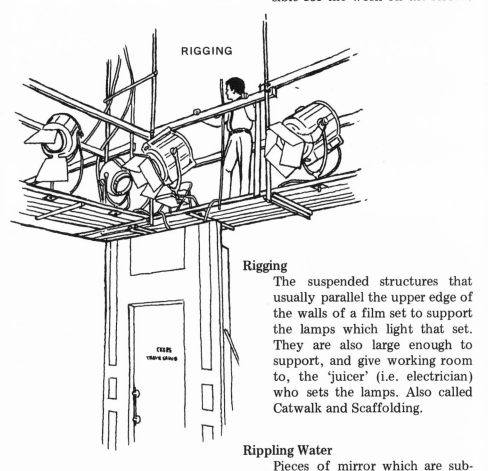

RIGGING

Rigging

The suspended structures that usually parallel the upper edge of the walls of a film set to support the lamps which light that set. They are also large enough to support, and give working room to, the 'juicer' (i.e. electrician) who sets the lamps. Also called Catwalk and Scaffolding.

Rippling Water

Pieces of mirror which are submerged in a long, flat pan so that when the pan is gently agitated,

the mirrors will reflect broken light on the actors, resembling the reflection from the surface of a lake.

Riser

A platform, a few inches in height, for raising a prop, actor or cameraman above the studio floor.

Road Show—Hard Ticket

Reserved seat performances of a film.

Rock In—Rock Out

When an actor places his weight on one leg to shift his balance and position into or out of the shot.

"Roll", "Roll 'em"

The order given, usually by the assistant director when the director believes the scene is ready to film, for the film camera and recording equipment to start functioning.

Room Tone

See Tone Track.

Rough Cut

The first assembly of the various scenes of a film into a somewhat comprehensive story order; usu-

ally with the dialogue and sound track.

'Rug'

A toupee. False hair to cover baldness.

Running Shot

Moving the camera to keep pace with the actors as they cross the set or exterior location.

Run Through

A shot in which the action is a car (or horse, stage coach, tank, etc.) being driven across in front of the camera.

Run Through

Usually a complete rehearsal of a scene, from beginning to end.

Rushes

Prints of the day's filming which are rushed through the laboratory during the night so they may be seen the next day. See Dailies.

S

SAG—Screen Actors Guild

The collective bargaining agency for all those who act in front of the camera in the motion picture industry. SAG negotiates wages and working conditions for actors and stunt men with the members of the Producers Association. Publication: *Screen Actors Magazine.* Yearly award given for outstanding achievement in fostering the finest ideals of the acting profession.

Screen Actors Guild

Sandbag

A canvas bag which is weighted with sand or lead pellets and used to place additional weight on the base of objects which might have a tendency to topple, such as a reflector, or lamp, stand.

"Save the Arcs", "Save the Lights"

To turn off lamps between takes when they're not needed. Saves on power, wear and tear on lamp bulbs, and keeps the temperature on the set bearable.

"Save the Food"

To fake the eating of the food during rehearsals of a scene until the actual take.

Scaffolding

See Rigging.

Scene Dock

The location on the lot for the storage of reusable set pieces such as walls, doors and window units.

School Room

An area set aside for the kids appearing in films so they can attend school when working. The teacher must be accredited by the state and is employed by the producer or studio.

Scoop

A bowl-shaped lamp which is used to illuminate a backing. Also called a Sky Pan.

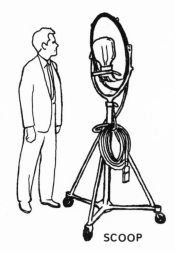

SCOOP

Score *n*

The music for the film.

Score *vb*

To write the music for the film.

Scoring

The music recording session.

Scouting

Looking for locations to film, or
for human talent.

Screen

A reflective surface on which the
film is projected for viewing by
the audience.

Screenplay

The completed script from which
the film is shot.

Screen Test

A filmed scene in which the ac-
tor is given a chance to show
what he can do. The scene is usu-
ally taken from the film for
which the actor is being consid-
ered and will be shot with ward-
robe, sets and make-up.

SCRIM

'Scriber'

The writer.

Scrim

A flag which is made of trans-
lucent material. Its effect is
partly to cut off, partly to dif-
fuse, the source of light. It is
midway between a gobo and a
diffuser.

Script *n*

The written work from which
the film is made. In the early

stages, the script is called a treatment; in its final stages, a shooting script.

Script *vb*

To write a script. "He's been set to script a 'Gunsmoke' seg."

'Scripter'

The writer of a screenplay.

Script Supervisor, Script Clerk

The person who is responsible for keeping a written record of all scenes and takes filmed, including all pertinent information such as the duration of the scene, the direction of movements in the scene (left to right, etc.), direction of looks, placement of actors and related props, and the physical moves that the actors may have to match in all subsequent coverage and for possible retakes. All of this information is entered in the script supervisor's copy of the script and is used by the editor when he's working on the film. Also included in this copy of the script may be notes to the editor from the director.

'Scrub'

An order to dispose of, destroy or remove an object, set or person. "Scrub the operating room set."

Second Unit

A film crew which is sent out to photograph the stunt work, auto races, forest fire, battle scenes, or other shots that do not necessarily require the presence of the stars and director. In these shots the stars are usually doubled by stunt personnel. The second unit also photographs the film which is used for rear projection.

Second Unit Director

The man responsible for directing the second unit filming. He must see to it that what he photographs will integrate with that of the first unit.

Security Department

The studio police department.

SEG—Screen Extras Guild

The labor union that negotiates wages and working conditions for extras in all phases of film work.

Seg

Segment. One program of a TV series.

SENIOR SPOT

Senior Spot

A 5000-watt lamp which is used to place a beam of light on a specific area of the set or actor.

Separate Action

Used in the case of an actor who must make an entrance into a scene when the camera is already rolling. The director may call "Action!" as a cue to the actor to make his entrance at the appropriate moment.

Sequence

A section of the film which is more or less complete in itself. A scene.

Series

A television show, in any of the usual lengths of time, in which there is some continuing character or concept.

Session

A recording, dubbing or filming job.

Set

A construction on a sound stage or exterior, which is built to represent what is required for the story; e.g. an office, kitchen, home, castle or battlefield.

Set Dresser

The man responsible for dressing the set. See "Dress the Set".

Set-Up

The specific arrangement of a set

and/or actors and camera for a
scene.

Sexploitation
The description of a film which
depends primarily on sexual in-
terest to attract an audience.

Shoot
To expose film (preferably
through a camera and lens) of a
subject that will sell tickets.

"Shoot Around You"
To continue filming a scene,
without involving one of the ac-
tors. Shooting around someone
sometimes requires a good deal
of re-arranging previous prepara-
tion on the part of the director.

Shooting Script
The final working script of a
film, detailing the shots one by
one and numbered in sequence.

Short
A film which is shorter than a
feature; usually three reels or less
and about 30 minutes, or less, in
length.

Short End(s)
The unexposed film which still
remains in the magazine, usually
because there wasn't enough film

left to do another take on the scene being shot.

Short Focus Lens

A relative description for a lens of shorter-than-normal focal length, giving a wider field of view. Also called a wide angle lens.

Shot

A single portion of the film which is photographed without stopping the camera. Also, a scene in the script which is designated by one number, without any interruption to another scene.

Shots, types of

Close or Close Up (CU), Dolly, Establishing, Extreme Close Up (ECU), 50-50, Follow, High, Insert, Long, Low, Medium (MS), Medium Close (MC), Medium Long (ML), Moving, Over-Shoulder, Re-action, Reverse, Running, Swish Pan, Tilting, Traveling, Trucking, Two, Zoom.

Shutter

The camera mechanism that prevents light from striking the film between frame measurements so that a separate series of photographs will be spaced evenly along the film being run through the camera.

Single

A shot of only one person or thing.

Single System Sound Recording

Sound which is recorded on the edge of the same strip of film as the picture. Used primarily for news photography so that one man can operate both camera and sound.

Sit-Com

A situation comedy.

"Sit into the shot."

A direction for the actor to take his position and be ready to sit on the chair, couch or wherever he's to sit so that on "Action!" he will sit.

Sked

Schedule.

Skin Flick

See Nudie.

Skull

See Take.

Sky Pan

See Scoop.

Slate Board

See Clapper Board.

"Slate It"
See "Mark It".

Slow Motion
Exposing the film at faster than the standard 24 frames per second, so that when it's projected at normal speed the action is slower than normal.

Sneak, Sneak Preview
The showing of a film at a neighborhood theatre, usually without previous announcement, so that the film makers can get an audience reaction to the film before putting it into general release. Sometimes this audience reaction is used to make changes in the film which the producers feel will make it more successful.

Soap, Soap Opera
A story that leans heavily on melodrama and over-emotionalism. Originally a term from radio when the daytime melodramas were sponsored by soap manufacturers.

Soft Focus
A shot in which the lens is thrown just slightly out of focus so that the subject matter appears fuzzy. Sometimes used when photographing the actress whose age is showing.

Soft Light

A lamp that provides an almost shadowless, overall illumination.

Sound Camera

A camera that operates silently while photographing, so that sound can be recorded without camera noise on the sound track.

Sound Department

Responsible for supplying, operating and maintaining the sound recording equipment used in the making of films.

Sound Effects

A recorded collection of sounds for use in films—from the sound of a fist hitting a jaw to a jet plane taking off. Because of the ability to control clarity and volume, these pre-recorded sound effects will often be used in preference to 'reality'.

Sound Effects

The sound track. All of the sounds, other than voices and music, which are necessary to the film. Before the composite, or final, print is made, the sound effects are usually recorded on a separate track or tracks.

Sound Effects Library

A catalogued collection of sound effects which have been recorded either on tapes or discs.

Sound Stage
See Stage.

Sound Tape
Magnetically-treated plastic tape, usually ¼-inch in width, which is used for recording sound.

Sound Track
A narrow band, along one side of the motion picture film, which carries the sounds in the film. In some cases, such as in stereophonic sound or for foreign release where the original music and effects will be retained but additional dialogue is dubbed, more than one band is used.

Sound Truck
A mobile unit, sometimes with a self-contained power system, which is fitted with sound recording equipment.

'Spec'
On speculation. To speculate on the success of a film by working on the project for deferred payment or a percentage of the possible profits.

Special Effects Department, Man
Responsible for all effects work done outside of the camera or film lab, such as explosions, fires, tidal waves and earthquakes.

Spectacular

A film project that is more expensive than any other, greater in scope than any other, more important than any other—but... aren't they all? Also, a television show that is unusual compared to regular programs.

Speed

The correct speed at which a film mechanism is designed to run so that the photographs taken will be what is wanted for the film. When the call "speed" is heard on the set, the sound and/or picture camera is running up to speed, i.e. at the proper speed for recording. Now the director can call "Action!"

Spex

Specials on television or a spectacular film.

Spider Box

A box on the end of a power line, into which many stage lamps can be plugged.

Spin Off

A pilot show for a new series, which is presented as an episode on a currently running series or anthology to test audience reaction.

Splice, Splicing

The joining together, end to end, of two pieces of film so that they form one, continuous piece. The process is called splicing; the connection is called a splice.

Split Screen

Two different scenes which appear on either side of a dividing line on the screen, either vertically or horizontally. May also be multiple images in different segments of the screen, or the filming of a scene in which one-half of the screen has been covered, exposing the other half to the actor being filmed, then vice versa so that the actor will appear to be talking to himself.

SPROCKET

Sprocket

A wheel with regularly-spaced teeth which engage the perforations on the edge of the film to move the film through the camera.

Squibs

Small containers which hold just enough powder to simulate a bullet hit. Squibs are fired electrically from a location off the set area.

Stage

The floor of the building in which filming takes place. It is

called a sound stage when used for shooting with sound, but both terms are used interchangeably.

Stage Brace

A metal pole, about six to eight feet in length, which is flattened on both ends so that it can be nailed to the back of a set wall and to the floor of the stage. The stage brace is placed behind flats and set pieces to support them so that the set won't wobble and sway when the door in the set wall is slammed by the leading lady. Braces are also made of wood with flat metal ends.

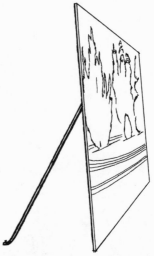

STAGE BRACE

Stand-In

A person, usually of the same sex, height and coloring as an actor in a film, who replaces the actor while the lights are being set and all the final preparations are being made for shooting the scene. The stand-in allows the actor to conserve his energy and possibly use the time for off-set rehearsal with the director and other actors. See Double.

Stanza

Usually refers to a single segment of a TV series. Derived from the musical term.

Star

The actor—male, female, child or animal—who has the leading role in the film. Also a person who has established himself as a lead in enough films, or has achieved enough publicity even without being in many films, so that he can attract ticket buyers to the box office and can make 'guest appearances' or perform in a 'cameo role' (less than a leading role) in a film.

Starlet

A young lady, usually in her early twenties but not yet a mature woman, who is old enough to be a leading lady. The starlet is on her way up the rungs of the ladder to stardom.

'Stay with the Money.'

To shoot a scene in such a way that the camera concentrates on the subject (star or action) the director (or producer) thinks will bring in the audience.

Still

A photograph. A single shot. Can be made from one frame of motion picture film.

Still Man, Photographer

Responsible for the taking of publicity and production photo-

graphs on the set and location. May also be utilized at special events, screenings, public appearance tours and premiers to photograph people and places for publicity purposes.

Stock Footage
A library of film footage, from newsreels, documentaries and feature films, which is considered useful in other films. The purpose for using stock footage from the library may be for historical authenticity and/or lower cost.

Stock Shot
A piece of film from the library.

Stop Frame
The repeat of one frame of the film to give the effect of freezing the action. Also called a freeze frame.

Stop Watch
A watch with a large sweep hand which can be started and stopped to measure the minutes, and fractions of minutes, of a take. Some stop watches also indicate the amount of film footage shot for the given length of time. The stop watch is usually carried by the script supervisor.

Story Board

A series of sketches which show the action in the film, or specific portions of the film, arranged in order, on a bulletin board, and captioned either with dialogue appropriate to the moment or a description of the scene. A story board is used to more easily, and economically, pre-plot the action.

Story Department

Responsible for the handling of the many scripts which are submitted to a studio. Scripts are read in the story department and either passed along to producers for possible production or returned to the author or his agent.

Story Editor

The person who reads submitted properties, (scripts, treatments, etc.) and does whatever rewriting may be necessary.

Stretch-Out

A six-passenger limousine which is used for the transportation of studio personnel.

"Strike"

To remove, as in the order "Strike that chair!"

Studio Departments

Art, Camera, Camera Machine Shop, Carpenter Shop and Mill, Construction, Costume, Drapery, Editorial, Electric, Fire, First Aid, Flowers, Foreign, Greens, Guards, Hairdressing, Legal, Location, Looping, Make-Up, Mimeograph, Music, Paint, Plumbing, Production, Projection, Property, Publicity, Ranch, Research, Security, Sound, Special Effects, Story, Telephone, Transportation, Trailer, Utility and Wardrobe.

Studio Manager

The person who is responsible for the smooth operation of all studio departments. Also called a plant manager.

Stunt Man, Woman

The person who takes the chances in the making of a film. When it comes to jumping off the roof, crashing the plane or taking the punch to the jaw, insurance costs, sanity and a shooting schedule demand that the actors be able to say their words, more so than perform physical activities which might endanger finishing the film on time.

Stuntmen's Association
of Motion Pictures

Stuntmen's Association of Motion Pictures

An association of stunt men and

women for the purpose of exchanging information and techniques. Stuntmen and women are also members of the Screen Actors Guild.

Subtitle
Words shown at the bottom of the picture which approximate the dialogue being spoken at the moment. Usually a translation into a language other than that spoken by the actors in the film. The use of subtitles is an alternative to voice dubbing.

Sunshade
Lens Shade. A rectangular box, increasing in size from the lens outward, that is attached to the camera in front of the lens to prevent light from striking the lens.

Super, Superimposure
The placing of one image over another which is already on the film, such as titles or language translation subtitles. See Dissolve.

Swish Pan
A panning movement in which the camera is moved quickly from one side to the other, causing the image on the film to blurr to create the idea of a rapid,

side-to-side movement of the
eyes. See Pan.

Synopsis

A very short version of the story,
without the details. Nothing but
the plot line.

Tachometer

Attached to a camera to measure the speed at which the camera is rolling film.

Tag, Tag Line

The closing line of a joke. The point at which the storyteller hopes his audience will laugh. Also, the last line or action of a scene, or the last scene of the film, which the director hopes will put the crowning touch on all that has preceded it.

Take

Each piece of action filmed.

Take

A physical reaction to an idea, made with the head (skull). A quick look. Sometimes indicated by a facial expression. Takes are done in doubles (twice), triples, etc. Also called a Skull.

"Take Camera"

An order from the director,

sometimes while the camera is still running at the end of a shot, for the actor to turn toward camera so that the audience will get the full effect of the final reaction. Or, when the director steps into the scene to demonstrate a piece of business during rehearsal, he may tell the actor to "take camera", i.e. to place himself where the camera will be during the shot so that he will see the action as the audience will see it.

Take Number

The consecutive number assigned to each scene as it is shot: Scene 28, Take 1; Scene 28, Take 2, etc. Parts of that scene that are then filmed are assigned consecutive letters after the scene number: Scene 28A, Take 1; Scene 28B, Take 1, etc. The letter designations are verbalized for the sound track by using proper names; e.g. Scene 28 Albany, Take 1; Scene 28 Boston.

Tank

A pool on the lot in which either an underwater scene can be shot (with the proper seaweed dressing installed) or the filming of miniatures can be made.

Tape

See Measuring Tape, Sound Tape, Video Tape.

Teaser

Either the first scene of the story or an excerpt from the story— usually one of the more exciting scenes—which is used to tease the audience into watching the rest. Used in television.

Tea-Wagon

The sound mixer's console. See Mixer.

Technical Advisor

Either assigned by the specialized group or employed by the studio to inform the director and cast about that specialized field; e.g. a doctor for a medical movie, a pilot for an air force movie.

Telephone Department

Responsible for processing the enormous amount of phone calls which come into, and go out of, the studio.

Tele-Photo Lens

A lens of greater-than-normal focal length which is used to bring distant objects closer.

Telepix

Feature-length films which are made for first showing on television.

Test
> The actual filming of a scene from the feature, or TV pilot, for which the actor is being considered. Usually complete with all the details that would be necessary to the finished product. See Personality Test, Reading.

"That's a Hold!"
> An order from the director to the script supervisor and camera assistant that the just completed take is not to go to the lab to be printed but is to be marked "hold" until other takes of the scene have been made and the director decides which of them he wants printed.

The Academy
> The Academy of Motion Picture Arts and Sciences.

The Business
> Show Business. The Biz. The many branches and facets of the entertainment industry.

Theme Music
> The main line, or melody, of the music which is written to accompany the film. The theme music may include lyrics.

The Workshops
> See FIWI.

'360'

A 360-degree camera coverage. A camera move in which the scene is filmed in continuous coverage in an arc of 360 degrees (a full circle), with the camera in the center of the circle looking out to the rim.

Tilting

Moving the camera in a vertical plane, up and down, as opposed to panning in a horizontal plane.

TILTING

'Tinseltown'

Hollywood. Actually, all the studios and their locations.

Title Music

Music, sometimes with lyrics, which is written to go with the titles (credits) of the film.

Tone Track

A sound track which reproduces the quality of background noise associated with a particular interior or exterior location. These are sounds which we are not usually consciously aware of but which provide a film with the necessary sense of reality.

Top Lighting

Light, from sources mounted above the subject, which shines down on it.

Track
> The sound or dialogue track of the film.

'Trades'
> The newspapers, both daily and weekly, that specialize in news of the film or entertainment business, including specialty publications for distributors, producers and directors.

'Trailer'
> Coming attractions. The filmed sales pitch. Excerpts from the films to be seen as the next attraction. They were originally called trailers because they were shown after the main feature.

Trailer Department
> Responsible for making the trailers that are to be shown in theatres and on TV.

Training Film
> A film which is made to teach a particular aspect of a job or occupation, such as army or telephone company training films.

Transportation Department
> Responsible for maintaining all studio vehicles, from large trailer truck rigs, used for transporting a film company to location, to executive limousines.

TRIPOD DOLLY

TROMBONE

Trapeze
> Allows suspension of lamps from overhead ropes or chains.

Traveling Shot
> See Dollying.

Treatment
> A detailed presentation of a story for a film, but not yet a script.

Triangle
> A three-pointed, usually folding or collapsible, device which is used to keep the three legs of a tripod from shifting when set up on a smooth surface.

Tripod
> A three-legged support which is usually used on location to hold the camera. Each of the legs is adjustable so that the tripod can be used on uneven surfaces and still keep the camera level.

Trombone
> An extendible hanger that can be attached to, or hung from, the set wall to support lamps.

Trucking
> See Follow Shots.

'Tub Thump'
> To publicize.

'Tub Thumper'

Publicist. From old medicine show days when the attention of the public was attracted to the show by the beating of a bass drum or tub.

'Tuner'

The music composer.

Two-Headed Nail

A nail which is used in the joining of set walls and other temporary construction on the soundstage and in film construction. It has a second head just below the usual one, which prevents the nail from being driven all the way into the wood, allowing for quick and easy removal when the set is to be torn down.

Two Shot

A shot containing two characters, usually close to the camera. A three shot contains three characters, and so on.

Two Step

A two-level box which is sometimes used to replace a chair in a close-up, low shot or over-the-shoulder shot. Also used as a ladder or a stand for props.

TWO STEP

UV

Underground Movies

Films which are made on an extremely low budget, without any connection to studios or unions.

Unit Manager

The person who is responsible for the smooth operation of a film company on location.

Up to Speed

See Speed.

Utility Department

The department that supplies the laborers and clean-up crews on the lot.

Variable Speed Motor

Varies the speed of the film running through the camera for special effects. Allows precise control.

Variety

A newspaper which is published weekly to present news of the

entertainment business as a whole, and daily to report specific news of the film business.

'Veepee'

Vice President of a company.

Vid

Short for video, referring to the *picture* part of television. Used as part of a word such as vidirector or vidpic.

Video

The electronic transmission or reception of an image (as opposed to audio, which refers to sound).

Video Tape

Magnetically treated tape—¼, 1 or 2 inches in width—which is used to record picture and/or sound. Sometimes used simultaneously with the film camera for instant replay.

Vidicon

An electronic camera tube in which a pattern is formed on a light conductive surface, and then transmitted.

'Vidoc'

A documentary film for television. (*Pl*, Vidox.)

Viewfinder
An optical instrument attached to the left side of the blimp, which enables the camera operator to follow the action while the camera is running.

Visuals
The picture (as opposed to sound).

Voice Cue
Usually a vocal signal from the director, or from an actor in the scene, that it is either time for an entrance by another actor or time for a particular piece of business.

Voice Over
Off-camera voices. V.O.

Walkie-Talkie

A small, hand-held portable sending-and-receiving radio set which is used on location where the director and his assistants may be too far from the action to be normally heard.

Wall Plate

A metal plate with a socket which is nailed to a set wall to hold lamps. Comes in baby and junior sizes.

Wall Sled

A lamp holder that can be hung over the top of a set wall. Called a sled because of its appearance.

'Warbler'

Singer, vocalist.

Wardrobe Box

A large box on wheels with doors and drawers which is used for the transporting and storage of wardrobe.

WARDROBE DOLLY

Writers Guild
of America

Wardrobe Call

An appointment for an actor to go for a wardrobe fitting.

Wardrobe Department

Responsible for the selection of the wardrobe to be worn in the film: clothing already owned by the talent, or costumes to be rented or designed and made for the film.

Wardrobe Man, Woman

The person who is responsible for the selection, purchase and maintenance of the wardrobe to be used in the film. Sometimes called the Wardrobe Mistress.

Weekly

An actor's contract arranged on a weekly basis. 'On a weekly.'

WGA—Writers Guild of America

The Professional guild that negotiates minimum salaries and working conditions for writers in motion pictures, television and radio.

Wild Line

A line that is usually recorded after a take, or at the end of the day's shooting. It may have been necessary to re-do the line from one of the scenes shot because it was not clear during the take, or

it was an idea thought of afterward.

Wild Recording
Any sound recording which is not made while photographing. Sound effects and random voices are usually recorded this way; sometimes narration and music, too. Also called Non-Sync.

Wind Machine
A large, electrically-driven propeller which is usually surrounded by a protective wire grid. It's used to create such conditions as sandstorms and wind effects.

Winds *vb*
"Filming winds today," i.e. ends, completes.

Wipe
An optical effect between two shots in which the second shot begins at an outer edge of the screen and wipes the first shot off along a visible line until it replaces it. The line may run vertically, horizontally, diagonally, or in a pattern. See Push-Over Wipe.

'Wired for Sound'
A member of SEG who may also be a member of SAG and, therefore, will be used to speak lines.

WIND MACHINE

In special instances, an extra will be required to say words.

Wireless Microphone
A small microphone that is actually a transmitter and can be worn by the actor in a scene where the mike boom is impractical.

Working Title
Whatever the film or televison series has been temporarily named for identification purposes. May or may not be changed for release.

Workprint
1. The first rough collection, put in a consecutive order, of all the takes that may go into the final film. The soundtrack is synchronized, and any other effects such as dissolves and fades are in place. 2. A soundprint which usually contains all of the tracks (original sound, effects, etc.) but is often without the final music score which, in most instances, is added to the finished film.

WORK LIGHT

Wrangler
The man responsible for the livestock used in a film.

"Wrap"
To complete, finish. "Filming of

the series wrapped today." Or, the order given, usually at the end of a day's shooting, to notify one and all that the day's work is at an end. Sometimes used before lunch, sometimes at the end of a scene, referring specifically to that scene. Also refers to the job of wrapping the set, i.e. collecting all props and covering furniture with dust covers to be ready for the following day's work.

"Wrong Set"

A statement sometimes made by the director or assistant director when a scene has been completed to indicate that the work in that set is finished and the company is now to move to the next set on the shooting schedule.

Young Leading Man or Woman
A performer between the ages of 20 and 25.

Zinger
A one-line response. Sometimes funny, but usually meant as a quick, verbal jab.

Zoom, Zooming
Rapid motion of the camera—either real or apparent—toward an object. Also applies when moving away from an object.

Zoom Shot
A shot taken with a zoom lens to bring objects in from a distance. Sometimes used instead of moving the dolly forward and backward.

FILM BUDGET BREAKDOWN

The Film Budget Breakdown which follows shows the scope involved in the preparation and production of a film—all the personnel and services which must be considered in any film production, including such diverse expenses as the music, props, animals, special effects, trick shots and insurance. The same scope applies to almost any film, whether it is a one-minute commercial, a single segment of a television series or a million-dollar feature, the only differences occuring in the details of what is actually needed for each film and how much of a budget is allocated for each. Even the so-called "underground" film, shot without unions, needs the same kind of jobs filled and the same accomplishments to complete the film.

The Film Budget Sheet (opposite) lists the major items which must be accounted for in each production. The numbers listed to the right of each item refer to the pages on which is found a more detailed breakdown.

FILM BUDGET

Type of Budget _____
Est. Start Photo. _____
Est. Finish Photo. _____

Series _____
Title _____

Date _____
Production No. _____
Exec. Prod. _____
Producer _____
Director _____

Schedule	Days	Actual Days	Budgeted Crew Hours	Actual Crew Hours				
Studio								
Location								
Total								

Act	Description	Page					
01	Script	172					
02	Supervision—Direction	172					
03	Cast	172					
04	Music	173					
06	Royls, Commissions, Fees, Rights	173					
07	Fixed Program Charges	173					
09	Contingency	173					
11	Taxes (other than payroll)	173					
14	Other						
	TOTAL ABOVE-THE-LINE	173					
71	Amortizations	173					
74	Set Construction	173					
75	Set Operation	174					
76	Property and Set Dressing	174					
77	Wardrobe	175					
78	Makeup and Hairdress	175					
79	Electrical	175					
80	Camera	176					
81	Sound	176					
82	Studio Transportation	177					
83	Special Equipment and Animals	177					
84	Location Transportation	178					
85	Location	178					
86	Special Effects	179					
87	Miniatures	179					
88	Process Photography	179					
89	Trick or Matte Shots	179					
90	Stock Shots	180					
91	Film	180					
92	Laboratory	180					
93	Opticals, Inserts, Titles, Trailers	181					
94	Editorial	181					
95	Production Staff	182					
96	Tests	182					
97	General Production Expense	182					
98	Fees	183					
99							
	TOTAL BELOW-THE-LINE						
	TOTAL BUDGET						

Production Manager _____

Producer _____

Estimator _____

171

DESCRIPTION	Time or Qty	Rate	Amt	Total
01—SCRIPT				
101 Writers' Salaries				
102 Story Editors' Salaries				
103 Rewrite and Polish				
104 Script Consultant				
105 Researcher				
107 Rights				
108 Abandoned Script Amort (incl. WGA and Fringe)				
109 Pension—WGA				
110 Payroll Taxes and Fringe Benefits				
111 Script Mimeo (A-T-L only)				
112 Script Delivery				
115 Miscellaneous				
02—SUPERVISION AND DIRECTION				
121 Producer				
122 Director				
123 Executive Producer (plus fringe)				
124 Associate Producer				
128 Legal and Technical Advisor				
131 Assistant to the Producer				
135 Program Secretaries				
141 Pension—DGA				
142 Payroll Taxes and Fringe Benefits				
154 Other Expense—Travel/Entertainment				
804 Space Rental				
879 Telephone				
03—CAST				
160 Running Principals				
161 Guest Stars				
162 Supporting Cast				
163 Bits, Stunts, Doubles				
164 Extras and Standins				
166 Teachers, Welfare Workers				
168 Casting Service—Half Hour				
169 Casting Service—One Hour				
172 Outside Casting Fees and Commissions				
173 Payroll Taxes and Fringe Benefits				
Running Principals and Supports (TVC)				
Supports and Stunts (SC)				

DESCRIPTION	Time or Qty	Rate	Amt	Total
03—CAST (Continued)				
SEG				
174 Pension—SAG				
Running Principals and Supports (TVC)				
Supports and Stunts (SC)				
SEG				
176 Miscellaneous Expense				
960 Sideline Musicians				
04—970 MUSIC				
06-185 ROYALTIES, COMMISSIONS, FEES, RIGHTS				
11-190 TAXES (other than Payroll)				
191 Insurance				
13—BUYOUT				
14—OTHER ABOVE-THE-LINE EXPENSE				
71—AMORTIZATION				
001 Pre-Production				
002 Post-Production				
003 Permanent Sets				
004 Layoff				
010 Other				
74—SET CONSTRUCTION				
001 Art Director				
002 Assistant Art Director				
003 Set Designers				
004 Sketch Artists				
005 Construction Supervisor				
031/040 Set Cost Labor				
045 Striking				
047 Storeroom Materials				
048 Backings				
052 Purchases				
053 Light Platform Rentals				
076 Rentals—outside				
090 Car Expense				
099 Construction Supervision				
118 Miscellaneous Expense				

DESCRIPTION	Time or Qty	Rate	Amt	Total
75—SET OPERATION				
001 Company Grip				
002 Second Company Grip				
003 Grips				
004 Boom/Dolly Grip				
005 Standby				
Extra Stage Cleanup				
006 Greensman				
007 Resets (company moves, folds and holds)				
008 First Aid				
009 Protection				
010 Craft Service				
031 Dressing Rooms—Portable (labor)				
Dressing Rooms—Rental				
047 Storeroom Materials				
052 Purchases				
076 Rentals				
077 Air Conditioning				
090 Car Expense				
096 Maintenance				
110 Meals				
118 Miscellaneous				
76—PROPERTY and SET DRESSING				
001 Set Decorator				
002 Swing Gang Lead				
Swing Gang				
003 Property Master				
004 Assistant Property Man				
005 Standby Propmen				
006 Drapery				
033 Electric Fixtures				
034 Flowers and Greens—Rentals				
040 Props—Manufactured				
047 Storeroom Materials				
052 Purchases—Props and Others				
053 Purchases—Set Dressing				
075 Contract Rentals				
076 Rentals—Set Dressing Other				
078 Hand Prop Rentals				

DESCRIPTION	Time or Qty	Rate	Amt	Total
76—PROPERTY and SET DRESSING (Continued)				
087 Damage and Loss				
090 Car Expense				
115 Cleaning and Dyeing				
118 Miscellaneous Expense				
78—WARDROBE				
001 Men Costumers				
002 Women Costumers				
003 Shop Labor				
004 Designers				
005 Wardrobe Allowance				
047 Storeroom Materials				
052 Purchases				
076 Rentals				
087 Damage and Loss				
090 Car Expense				
115 Cleaning and Dyeing				
118 Miscellaneous				
78—MAKEUP and HAIRDRESS				
001 Makeup Artists				
002 Hair Stylists				
003 Body Makeup				
004 Shop Labor				
047 Storeroom Materials				
052 Purchases				
076 Rentals				
090 Car Expense				
118 Miscellaneous Expense				
79—ELECTRICAL				
001 Gaffer				
002 Best Boy				
003 Operators				
004 Generator Man				
005 Rigging				
006 Striking				
007 Worklights				
047 Storeroom Materials				
052 Purchases				
053 Current				

DESCRIPTION	Time or Qty	Rate	Amt	Total
79—ELECTRICAL (Continued)				
076 Rentals—Outside				
077 Rentals—Studio				
086 Burnouts and Diffusion				
096 Maintenance				
118 Miscellaneous Expense				
80—CAMERA				
001 Director of Photography				
002 Camera Operators				
003 First Assistant Cameraman				
004 Second Assistant Cameraman				
005 Color Technician				
006 Loader				
007 Still Cameraman				
047 Storeroom Materials				
052 Purchases				
076 Camera Rentals				
079 Crane or Dolly Rentals				
096 Maintenance				
116 Negative Selection				
118 Miscellaneous Expense				
81—SOUND				
001 Mixer				
002 Recorder				
003 Boom Man				
004 Cable Man				
005 Playback Operator				
006 Operator—P.A.				
030 Transfers—Dailies				
031 Transfers—Effects				
032 Transfers—Reprints and other				
033 Transfers—½" Mag. Tape				
034 Transfers—Music				
035 Transfers—Optical				
036 Sound Effects				
037 Transfers—Special Handling and Transfer to ¼" Tape				
076 Production Sound Equipment Rental				
077 Re-Recording				

176

DESCRIPTION	Time or Qty	Rate	Amt	Total
81—SOUND (Continued)				
078 Re-Recording Credit				
079 Scoring				
080 Playback Rental				
081 P.A. Rental				
082 Line Replacement				
111 Royalties				
116 Sales Tax				
118 Miscellaneous Expense				
82—STUDIO TRANSPORTATION				
001 Driver Gang Boss				
002 Dispatcher				
004 Construction Transportation				
005 Set Operation Transportation				
006 Property Transportation				
007 Wardrobe Transportation				
008 Makeup/Hairdress Transportation				
009 Electrical Transportation				
010 Camera Transportation				
011 Sound Transportation				
013 Special Equipment/Animals Transportation				
016 Special Effects Transportation				
017 Miniatures Transportation				
018 Process Transportation				
024 Editorial Transportation				
026 Tests Transportation				
117 Gas and Oil				
118 Miscellaneous Expense				
83—SPECIAL EQUIPMENT and ANIMALS				
001 Animal Trainers				
002 Wrangler Lead				
003 Wranglers				
004 Special Equipment Operators				
076 Horses				
077 Cattle				
078 Other Animals				
079 Wagons				
080 Picture Cars				
081 Boats				

DESCRIPTION	Time or Qty	Rate	Amt	Total
83—SPECIAL EQUIPMENT and ANIMALS (Continued)				
082 Airplanes/Helicopters				
083 Trains				
104 Special Insurance				
105 Feed				
117 Gas and Oil				
118 Miscellaneous Expense				
84—LOCATION TRANSPORTATION				
001 Driver Captain				
002 Drivers				
004 Load and Unload for Location				
050 Fares to and from Location				
051 Parcel Post and Freight				
074 Auto Rental				
075 Bus Rental				
076 Truck Rental				
077 Camera Car Rental				
078 Sound Truck Rental				
079 Water Wagon Rental				
080 Honey Wagon Rental				
081 Miscellaneous Rental				
117 Gas and Oil				
118 Miscellaneous Expense				
85—LOCATION				
001 Location Manager				
002 Location Auditor				
003 Police				
004 Firemen				
005 Watchmen				
006 First Aid				
007 Local Hire				
010 Gratuities				
050 Meals				
051 Hotel				
052 Purchases				
076 Site Rentals				
077 Rentals—Other				
091 Location Survey Expense				
118 Miscellaneous Expense				

DESCRIPTION	Time or Qty	Rate	Amt	Total
86—SPECIAL EFFECTS				
001 Rigging				
002 Striking				
003 Operating				
004 Standby Effects Man				
005 Other Operators				
047 Storeroom Materials				
052 Purchases				
076 Rentals				
096 Maintenance				
118 Miscellaneous Expense				
87—MINIATURES				
001 Construction				
002 Striking				
003 Operating				
004 Cameramen				
047 Storeroom Materials				
052 Purchases				
076 Rentals				
118 Miscellaneous Expense				
88—PROCESS PHOTOGRAPHY				
001 Pre-Stage Photography				
002 Stage Labor (Projection and Front Man)				
052 Purchases—Background Plates				
053 Lab Expense—Background Plates				
076 Rentals				
077 Process Equipment—Rental				
118 Miscellaneous Expense				
89—TRICK or MATTE SHOTS				
001 Manufacture				
002 Photography				
003 Operating				
009 Negative Raw Stock				
014 Art Work				
047 Storeroom Material				
052 Purchases				
076 Rentals				
118 Miscellaneous Expense				

DESCRIPTION	Time or Qty	Rate	Amt	Total
90—STOCK SHOTS				
001 Crew				
002 Librarian Search Time				
052 Purchases				
053 Miscellaneous Processing				
076 Rental				
118 Miscellaneous Expense				
91—FILM				
009 Negative Raw Stock—35mm				
011 Negative Raw Stock—Still				
012 Negative Raw Stock—35/32 Sound (16 sound)				
013 35mm EKG Sound				
020 Leader				
029 Magnetic Reclaimed Single Stripe				
030 Magnetic ½"				
031 Magnetic 17-½mm				
032 Magnetic Stripe—Spliced				
033 Magnetic Stripe—Unspliced				
034 Magnetic Full Coat				
035 Magnetic ¼"				
118 Miscellaneous Expense				
92—LABORATORY				
010 Develop Negative				
011 Develop Negative Sound—35mm				
35/32				
014 Daily Prints (Color)				
015 Daily Prints (Black and White)				
026 Temp. Reversal Dupe Prints				
032 Answer Print—(1st Trial) 35mm				
033 Answer Print—(1st Trial) 16mm				
034 Composite Replacement Sections—35mm				
035 Protection Fine Grain or Interpositive—composite				
036 Protection Fine Grain or Interpositive—picture				
038 Reduction Dupe Negative—16mm				
040 Release Prints—35mm				
041 Relase Prints—16mm				
050 Negative Retouch				
051 Cellizing				
115 Reprints				

DESCRIPTION	Time or Qty	Rate	Amt	Total
92—LABORATORY (Continued)				
116 Cinex Tests				
118 Miscellaneous Expense				
215 Sound Print				
93—OPTICALS, INSERTS, TITLES, and TRAILERS				
OPTICALS				
010 Develop Negative for Opticals				
014 Optical Effects				
015 Print—Opticals				
017 Fine Grain or Interpositives (Color)				
for Opticals				
019 Dupe Negatives or Internegative (Color)				
118 Miscellaneous Expense				
INSERTS				
020 Inserts				
TITLES				
060 Production Titles (Contracts)				
061 Main Titles				
062 Opening/Closing Titles				
063 End Titles				
065 Act Breaks, Showcards, Bumpers				
TRAILERS				
201 Editing Labor—Trailer				
214 Opticals and Dupe Negative for Trailer				
217 Fine Grains for Trailer				
218 Titles and Misc. Expense—Trailers				
226 Temporary Reversal Dupe Prints—Trailers				
232 Release Printing—Trailers				
278 Dubbing, etc—Trailers				
94—EDITORIAL				
001 Film Editors				
002 Assistant Film Editors				
003 Apprentices				
005 Looping Editing Labor				
006 Librarian				
007 Negative Cutting				
008 Continuities				
009 Sound Effects Editing				
010 Music Editing				

DESCRIPTION	Time or Qty	Rate	Amt	Total
94—EDITORIAL (Continued)				
011 Sound Effects Rental				
035 Projectionist				
076 Equipment Rental				
077 Projection Room Rental				
078 Cutting Room Rental				
118 Miscellaneous Expense				
95—PRODUCTION STAFF				
001 Production Manager				
002 Unit Manager				
003 First Assistant Director				
004 Second Assistant Director				
005 Script Supervisor				
006 Production Assistant				
007 Technical Advisor				
118 Miscellaneous Expense				
96—TESTS				
001 Staff				
002 Crew				
047 Storeroom Materials				
052 Purchases				
076 Rentals				
118 Miscellaneous Expense				
97—GENERAL PRODUCTION EXPENSE				
043 Timekeeping—Payroll				
050 Postage				
051 Shipping and Express				
053 Telephone and Telex				
055 Messenger Service				
068 Packing and Crating				
076 Studio Equipment Rentals				
077 Studio Facilities Rentals				
078 Teleprompter Rentals				
085 Steno—Production Mimeo				
102 Medical				
104 Accrual for Retroactive				
105 Insurance				
111 Seal				

DESCRIPTION	Time or Qty	Rate	Amt	Total
97—GENERAL PRODUCTION EXPENSE (Continued)				
113 Legal				
114 Publicity				
118 Miscellaneous Expense				
120 Other (Accounting use only)				
125 Late Charges				
98—FEES				
001 Stage Rental				
002 Administrative Fees				
003 Production Fees				
004 Operations Service Charge				
005 Surcharges				
010 Other				

FILM INDUSTRY DIRECTORY

For your convenience, the names and addresses of the major West Coast guilds and unions, organizations and associations, industry publications and film studios are listed in alphabetical order on the following pages.

GUILDS AND UNIONS

Actors Equity Association
6430 Sunset Boulevard, Los Angeles, California 90028

American Federation of Television & Radio Artists
1551 North La Brea, Los Angeles, California 90028

American Guild of Musical Artists
Room 603, 6430 Sunset Boulevard, Los Angeles, California 90028

American Guild of Variety Artists
6513 Hollywood Boulevard, Los Angeles, California 90028

Artist's Managers Guild
7046 Hollywood Boulevard, Los Angeles, California 90028

Call Bureau
8480 Beverly Boulevard, Los Angeles, California 90048

Screen Actors Guild
7750 Sunset Boulevard, Los Angeles, California 90046

Screen Extras Guild, Inc.
3629 Cahuenga Boulevard, Los Angeles, California 90028

ORGANIZATIONS AND ASSOCIATIONS

Academy of Motion Picture Arts and Sciences
9038 Melrose Avenue, Los Angeles, California 90069

Academy of Television Arts and Sciences
Suite 200, 7188 Sunset Boulevard, Los Angeles, California 90046

American Cinema Editors
422 South Western Avenue, Los Angeles, California 90005

American Film Institute
501 North Doheny Road, Beverly Hills, California 90212

American Humane Association, The
8467 Beverly Boulevard, Los Angeles, California 90048

American Society of Cinematographers
1782 North Orange Drive, Los Angeles, California 90028

American Society of Lighting Directors, Inc.
4949 Hollywood Boulevard, Los Angeles, California 90027

ANTA
10944 Ventura Boulevard, North Hollywood, California 91604

ASCAP
9301 Wilshire Boulevard, Beverly Hills, California 90210

Association of Motion Picture & Television Producers, Inc.
8480 Beverly Boulevard, Los Angeles, California 90048

Celebrity Service
8746 Sunset Boulevard, Los Angeles, California 90069

Commercial Film Producers Association
15300 Ventura Boulevard, Sherman Oaks, California 91403

Credit Association, Motion Picture & Television
1725 Beverly Boulevard, Los Angeles, California 90026

Credit Interchange
1725 Beverly Boulevard, Los Angeles, California 90026

Film Industry Workshops, Inc.
4063 Radford Avenue, Studio City, California 91604

Friars Club of California, Inc., The
9900 Santa Monica Boulevard, Beverly Hills, California 90212

Hollywood Foreign Press Association
Room 290, 8732 Sunset Boulevard, Los Angeles, California 90069

Independent Producers Association
1765 North Sycamore Avenue, Los Angeles, California 90028

Masquers, The
1765 North Sycamore Avenue, Los Angeles, California 90028

Motion Picture Country House & Hospital
23388 Mulholland Drive, Woodland Hills, California 91364

Motion Picture Health and Welfare
606 North Larchmont, Los Angeles, California 90004

Motion Picture Industry Pension Plan
7423 Beverly Boulevard, Los Angeles, California 90036

Motion Picture & Television Comptrollers Association
7755 Sunset Boulevard, Los Angeles, California 90046

Motion Picture and Television Relief Fund
335 North La Brea Avenue, Los Angeles, California 90036

Motion Picture Sound Editors
Box 8306, Universal City, California 91608

National Academy of Recording Arts & Sciences
6430 Sunset Boulevard, Los Angeles, California 90028

Permanent Charities Committee
463 North La Cienega Boulevard, Los Angeles, California 90048

Producer-Writers Guild of America Pension Plan
8455 Beverly Boulevard, Los Angeles, California 90048

Radio & Television News Association of Southern California
809 North Cahuenga Boulevard, Los Angeles, California 90038

Radio & TV News Directors Association
3321 South La Cienega, Los Angeles, California 90016

Southern California Theatre Owners Association
Suite 508, 8530 Wilshire Boulevard, Beverly Hills, California 90211

Stuntman's Association of Motion Pictures, Inc.
15300 Ventura Boulevard, No. 301, North Hollywood, California 9140(

Theatre Authority, Inc.
6253 Hollywood Boulevard, Los Angeles, California 90028

PUBLICATIONS

Academy Players Directory
9011 Melrose Avenue, Los Angeles, California 90069

Action (D.G.A.)
7950 Sunset Boulevard, Los Angeles, California 90046

American Cinematographer
1782 North Orange Drive, Los Angeles, California 90028

Billboard, The
9000 Sunset Boulevard, Los Angeles, California 90069

Box Office
6331 Hollywood Boulevard, No. 709, Los Angeles, California 90028

Broadcasting Magazine
1680 North Vine Street, Los Angeles, California 90028

Celebrity Service
8746 Sunset Boulevard, Los Angeles, California 90069

Cinema Magazine
9667 Wilshire Boulevard, Beverly Hills, California 90212

Cinemeditor
422 South Western Avenue, Los Angeles, California 90005

Entertainment World
6548 Sunset Boulevard, Los Angeles, California 90028

Fame
6305 Yucca Street, Los Angeles, California 90028

Film Daily
6425 Hollywood Boulevard, Los Angeles, California 90028

Hollywood Film Productions Manual
1036 North Aron Street, Burbank, California 91505

Hollywood Reporter
6715 Sunset Boulevard, Los Angeles, California 90028

International Motion Picture Almanac
6305 Yucca Street, Los Angeles, California 90028

International Photographer
7715 Sunset Boulevard, Los Angeles, California 90046

International Television Almanac
6305 Yucca Street, Los Angeles, California 90028

Journal of the Producers Guild of America, The
141 El Camino Drive, Beverly Hills, California 90212

Motion Picture Daily
6305 Yucca Street, Los Angeles, California 90028

Motion Picture Herald
6305 Yucca Street, Los Angeles, California 90028

Pacific Coast Studio Directory
6331 Hollywood Boulevard, Los Angeles, California 90028

Variety
6404 Sunset Boulevard, Los Angeles, California 90028

West Coast Theatrical Directory
Suite 210, 9110 Sunset Boulevard, Los Angeles, California 90069

Writers Guild Newsletter
8955 Beverly Boulevard, Los Angeles, California 90048

STUDIOS

Aldrich Studio, The
201 North Occidental Boulevard, Los Angeles, California 90026

Allied Artist Pictures Corp.
9255 Sunset Boulevard, Los Angeles, California 90069

American International Productions
9033 Wilshire Boulevard, Beverly Hills, California 90211

Cascade California
6601 Romaine Street, Los Angeles, California 90038

CBS Studio Center
4024 Radford Avenue, Studio City, California 91604

Cinema General Studios
800 North Cahuenga Boulevard, Los Angeles, California 90038

Columbia Pictures
4000 Warner Boulevard, Burbank, California 91503

Culver City Studios, Inc.
9336 West Washington Boulevard, Culver City, California 90230

Disney, Walt Productions
500 South Buena Vista, Burbank, California 91503

General Service Studios
1040 North Las Palmas Avenue, Los Angeles, California 90038

Metro-Goldwyn-Mayer, Inc.
10202 West Washington Boulevard, Culver City, California 90230

Paramount Pictures Corporation
5451 Marathon Street, Los Angeles, California 90038

Producers Studio, Inc.
650 North Bronson Avenue, Los Angeles, California 90004

20th Century-Fox Film Corporation
10201 West Pico Boulevard, Los Angeles, California 90064

Universal Pictures
100 Universal City Plaza, Universal City, California 91608

Warner Brothers, Inc.
4000 Warner Boulevard, Burbank, California 91503

"THAT'S A WRAP"